IMAGES
of America

HIGHLAND PARK

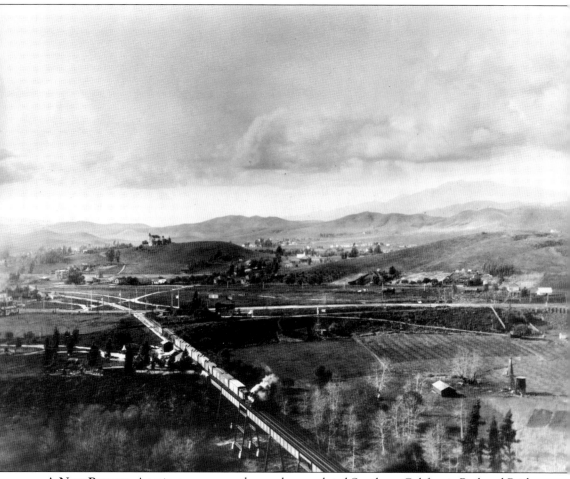

A New Bridge. A train crosses over the newly completed Southern California Railroad Bridge in 1896. The railroad was a wholly owned subsidiary of the Atchison, Topeka, and Santa Fe Railroad. The Santa Fe operated the line until 1993, when it was acquired by the Metropolitan Transit Authority as a link on the Pasadena Gold Line. The bridge is the oldest over the Arroyo Seco and is listed as Los Angeles City Historic Cultural Monument No. 339. (Security Pacific Collection, Los Angeles Public Library.)

On the Cover. The Highland Park community comes out to celebrate a special opening at the Highland Theater around 1936. These special occasions happened from time to time when the area still held its small-town appeal. The Highland was one of three movie venues on the newly renamed Figueroa Street. It is the only remaining one today. (Virginia Neely collection.)

IMAGES
of America

HIGHLAND PARK

Charles J. Fisher and the Highland Park Heritage Trust

ARCADIA
PUBLISHING

Published by Arcadia Publishing
Charleston SC, Chicago IL, Portsmouth NH, San Francisco CA

Printed in the United States of America

Library of Congress Catalog Card Number: 2007928968

For all general information contact Arcadia Publishing at:
Telephone 843-853-2070
Fax 843-853-0044
E-mail sales@arcadiapublishing.com
For customer service and orders:
Toll-Free 1-888-313-2665

Visit us on the Internet at www.arcadiapublishing.com

To Sally Beck, David Cameron, and Tom Owens,
who taught me the ropes of history

CONTENTS

ACKNOWLEDGMENTS

Highland Park would be a very different place today if it were not for those who have worked to preserve its history by preserving the built environment. The Highland Park Heritage Trust was founded by people who knew what they were losing. We were babes in the woods and sought help from those who had been there before. The late Los Angeles historian David Cameron gave us inspiration and the ability to successfully write landmark nominations. I learned how to dig through archives full of deeds, planning reports, and other resources through his assistance and also that of Sally Beck. Tom Owen, whose death in 2000 left a void in every historian's life, was an irreplaceable resource at the Los Angeles Public Library.

A special thank-you goes to Virginia Neely. Without her knowledge and extensive collection of articles and photographs, this work would not have been possible. I owe a great debt to both my editor at Arcadia Publishing, Hannah Carney, and my lovely wife, Anne Marie Wozniak, for supporting, prodding, and guiding me through this adventure.

Thanks to Pam Hannah and the Braun Research Library, Autry National Center, for use of the photographs from the Southwest Museum Collection on pages 29, 31–34, 52, 53, 86, and 103.

Without the help and photographs from the Los Angeles Public Library, this book would not have been produced. A special thank-you goes to Carolyn Kozo Cole and her staff for permission to use the many images from their collection.

Thanks also to Tim and Mari Parker, along with Troy and Heather McLarty, who loaned me many historic photographs of their incredible houses and the people who called them home over the years.

To my clients who allowed me time to finish this project, as well as Richard Starzak at Jones and Stokes, who allowed me the time away from critical projects: Thank you! Thank you! Thank you!

And finally I am grateful for the inspiration and encouragement of friends who have written Arcadia books before me: Glen Duncan (*Route 66*) and Jeff Sumudio and Portia Lee (*Los Angeles*). Without your lead, I would never have finished this.

INTRODUCTION

Highland Park was one of many subdivisions that were laid out during the Southern California land boom of the 1880s. While most of these early subdivision names faded into history, Highland Park would survive and prosper.

The land was first settled some 30,000 years ago by the ancestors of today's Chumash, who would move farther north when a branch of the Shoshone tribe known as the Tongwa settled in the area. These were the people that the Spaniards found when the original expedition led by Gaspar de Portola first explored the area in 1769.

A small scouting party had been sent up from the village of Yang Na, which would become the original Pueblo de Los Angeles. The party came to a dry wash, which was noted by the diarist as an *arroyo seco*. For some reason, the descriptive term, which was appropriate for the early summer, would become the name of a creek that now always flows but was merely underground at the time of its discovery.

The Mission San Gabriel was established soon after, and the Tongwa were renamed the Gabrielenos by the Spanish in reference to the mission. As several of the long-term soldiers at the mission garrison began to acquire cattle, they asked for and received grazing rights. Jose Maria Verdugo was the corporal of the guard at the mission.

On October 20, 1784, he was granted the 36,403-acre Rancho San Rafael by California governor Pedro Fages. Verdugo retained his grant until his death in 1830, when it was left to his son Julio and his daughter Catalina. An ill-advised loan in 1861, followed by a disastrous drought that decimated the Southern California cattle industry, cost the Verdugos the vast majority of their land.

In 1869, the Los Angeles County Sheriffs Department held a sale that put the future Highland Park land in the hands of Andrew Glassell Jr. and Albert Beck Chapman. Glassell and Chapman leased the land to sheepherders over the next few years. They eventually sold it to George W. Morgan and Albert H. Judson, who had just subdivided the adjacent land, which had been owned by the late Jesse D. Hunter.

Judson and Morgan subdivided the land in 1886, referring to it as the Highland Park Tract. The timing seemed perfect with land sales going through the roof as people scrambled to get their place in the Southern California sunshine. Just as the land began to sell, the boom went bust in 1888 and sales slowed to a trickle. While other subdivisions went broke, Highland Park, along with the adjacent town of Garvanza, slowly grew. That growth never stopped, and today Highland Park is home to about 50,000 people as a suburb of the city of Los Angeles, to which it was annexed in 1895.

People have always worked to make the area a better place to live—from the Greater Highland Park Association of the 1920s to the Highland Park Neighborhood Association of the 1980s and the Historic Highland Park Neighborhood Council of today. There were also individuals like Charles Fletcher Lummis, the most revered and dynamic individual to have called Highland Park his home. Attending Harvard, walking across the Southwest (a term he coined), championing the rights of Native Americans, revamping the Los Angeles Public

Library, overcoming physical adversity, and founding the Southwest Museum are but some of Lummis's amazing stories.

The founding of the Highland Park Heritage Trust in 1982 marked a change of direction for Highland Park, which, saddled with high-density zoning, was rapidly losing its historic buildings to the bulldozer. Ultimately, it would have become yet another mass of strip malls and stucco boxes had the heritage trust and others not intervened. Highland Park is now the home of the largest Historic Preservation Overly Zone (HPOZ) in Los Angeles. Established in 1994 as the seventh HPOZ in the city, it was the first to include a substantial commercial district as well as the residential area. This also became a major factor when the Metropolitan Transportation Authority brought the Pasadena Gold Line light rail through the area, replacing in part a street rail system that had been lost some 40 years earlier.

Highland Park is now an area that takes pride in its heritage with a dynamic population even more rooted in community investment than in the recent past.

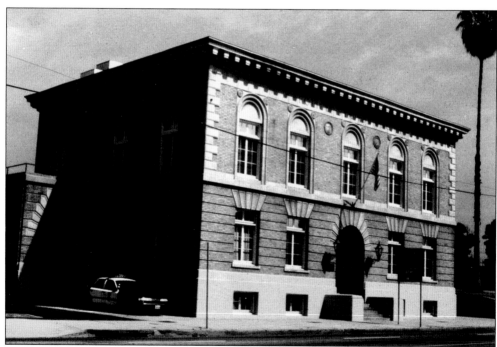

OLD NORTHEAST POLICE STATION. Built in 1923, the police station was replaced in 1983 by a new structure in the Atwater Village area. The Highland Park Heritage Trust wrote its very first Historic Cultural Monument application to save the building from demolition. Today as City Monument No. 274, the old station is the home of the Los Angeles Police Department Museum, as shown in this 2004 image. (Photograph by the author.)

One

BORN OF THE BOOM

Some communities are planned and others just come into being. Highland Park falls in the latter category, rising from the great Southern California land boom of the 1880s. Andrew Glassell Jr. and Albert Beck Chapman, two local attorneys, bought the land in an 1869 sheriff's sale that ended years of litigation resulting from a defaulted $3,500 loan that Julio Verdugo had taken out against his Rancho San Rafael in 1861. The drought that followed had decimated the cattle industry, causing many of the land grantees to default and lose their holdings.

Chapman and Glassell opted to lease out the 2,296.11-acre tract for sheepherding while they tended to other ventures in what was to become Orange County. The area was open grassland, dotted with California live oak and the Nogales, or black walnut. The main road to the new town of Pasadena passed through the site, from Sycamore Grove up to where it crossed the Arroyo Seco in present-day Garvanza into South Pasadena. Sycamore Grove was owned by Jessie D. Hunter, who had acquired his land directly from Verdugo prior to the ill-fated loan. Hunter had arrived in Los Angeles as a captain in the Mormon Battalion in 1846. He decided to settle in Los Angeles, sent for his wife and children, and established the first kiln-fired brickyard in the young city. Eventually retiring after an injury, Hunter took up ranching, purchasing the adjacent Rancho Cañada de Los Nogales and then additional land from Verdugo.

After Hunter's death in 1882, the family sold the land to George W. Morgan and Albert H. Judson, who then subdivided the Hunter Highland View Tract, which was the first subdivision in the area.

In 1885, Glassell and Chapman sold what became known as the Highland Park Tract to Judson and Morgan. The land was subdivided as farm parcels, and Highland Park was born in 1886. That same year marked the arrival of the Los Angeles and San Gabriel Railroad, which traveled directly though Highland Park.

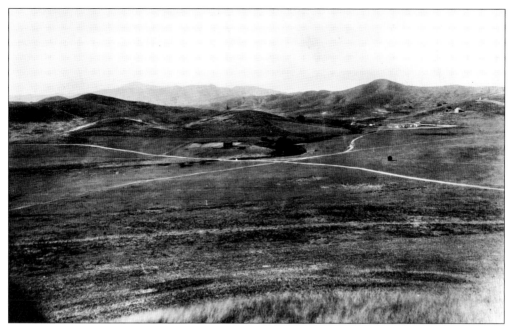

EARLY CROSSROADS. Two dusty roads are seen from Sugar Loaf in the 1880s. The North Fork of the Arroyo Seco flows out of the Annandale Valley. Poppy Peak is visible just to the right of the valley. When the railroad came a few years later, Sugar Loaf faded and the name Santa Fe Hill took its place, from the railroad at its base. (Photograph by Isaiah West Tabor, Los Angeles Public Library.)

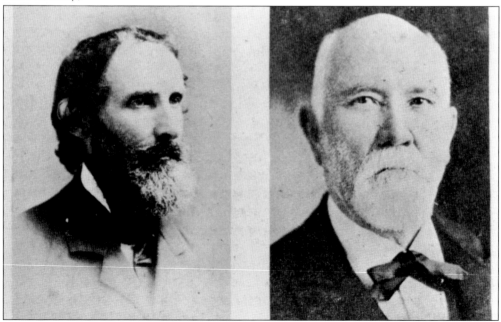

OWNERS OF THE LAND. Andrew Glassell Jr. (left) and Albert Beck Chapman (right) acquired the land in 1869 from Julio Verdugo after the courts had forced the sale to clear Verdugo's debt, at $1 per acre. The Rancho San Rafael was still 13 years away from having its federal patent, so the two lawyers opted to lease it out for the grazing of sheep. (Highland Park Heritage Trust.)

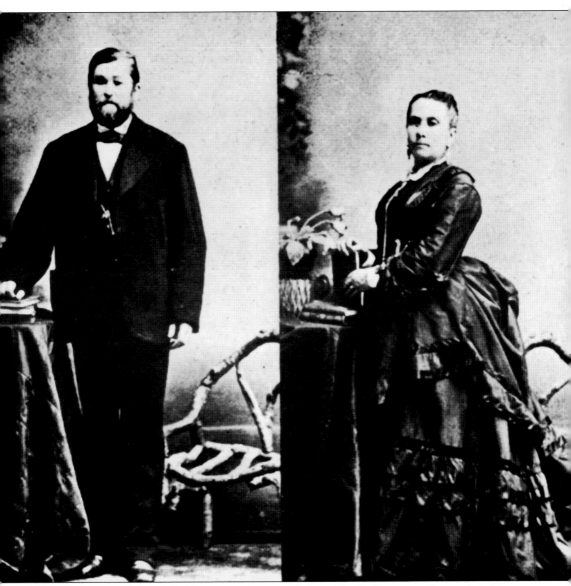

SHEEP RANCHERS. Miguel Goldaracena, shown with his wife, Paulin, was a Basque immigrant from Spain who made his money in the Los Angeles hotel business. The couple leased the land from Glassell and Chapman in 1871 to graze their extensive herd of sheep. There was an adobe on what is now Avenue 54 and a herder's camp at what would become the Highland Park campus of Occidental College. (*The Five Friendly Valleys.*)

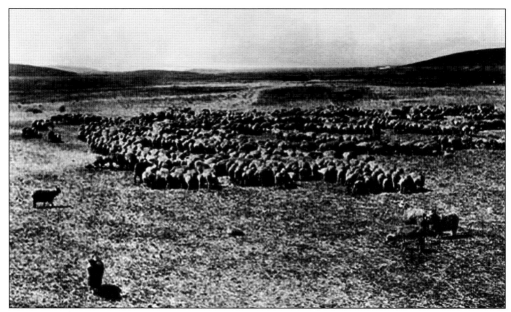

SHEEP GRAZING. The Goldaracenas' sheep graze in the center of what would soon be Highland Park. Sheep graze the wild grasses close to the ground, so there probably was not a very big fire danger in the area at that time. (Security Pacific Collection, Los Angeles Public Library.)

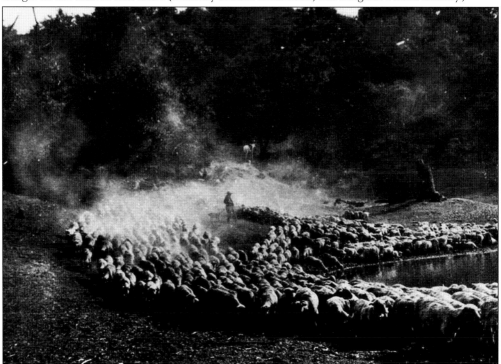

SHEEP AT JOHNSTON'S LAKE. In 1878, a shepherd oversees his flock as the sheep drink from the only natural lake in the area. Located just north of Highland Park in what is now part of Pasadena, the lake still exists today, as a private body surrounded by housing. (Security Pacific Collection, Los Angeles Public Library.)

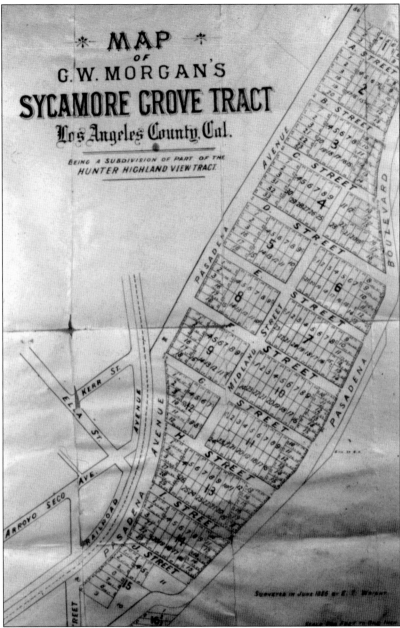

MAP OF SYCAMORE GROVE. George W. Morgan and Albert H. Judson purchased the southern portion of the Rancho San Rafael, along with most of the Rancho Cañada de Los Nogales, from the estate of Jesse D. Hunter. The federal patents for both ranchos had just been issued, but the San Rafael boundaries included the half-league rancho that had been carved out by Gov. Manuel Micheltorena in 1844 and granted to Jose Maria Verdugo. That rancho, which encompasses Glassell Park and part of Mount Washington today, was never recorded in Los Angeles County and was thus soon forgotten. Judson and Morgan subdivided the Hunter Highland View Tract, and Morgan created the first tract for individual homes in the area, pictured here. Charles F. Lummis eventually purchased lots 11 through 23 in Block 4 for his home, El Alisal. (Southwest Museum collection.)

13

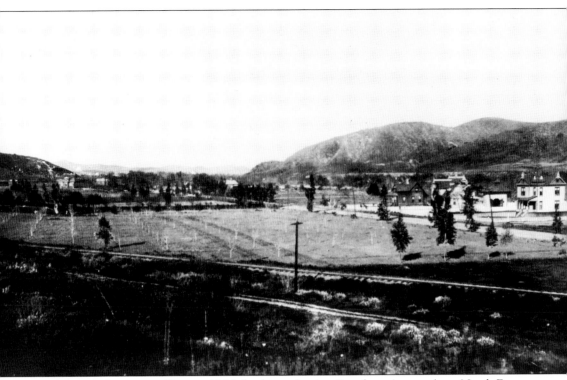

MORGAN'S SYCAMORE GROVE, 1886. In this early view, Pasadena Avenue (now North Figueroa Street) heads north through the area then known as Sycamore Grove, which was situated within the Pueblo Grant for the city of Los Angeles, as well as the Rancho San Rafael. The house on the far right, which belonged to banker William Washborn, was severely damaged by fire in the early 1980s and demolished in 1993 for a coin-operated car wash. The house on the left, where the hill comes down, was George Morgan's home, designed by W. R. Norton. It was transported to an adjacent lot in 1900 by James G. and Bessie Hale. In 1970, the Hale House was moved to Heritage Square. The name Sycamore Grove eventually disappeared except for the park, located to the north. (Security Pacific Collection, Los Angeles Public Library.)

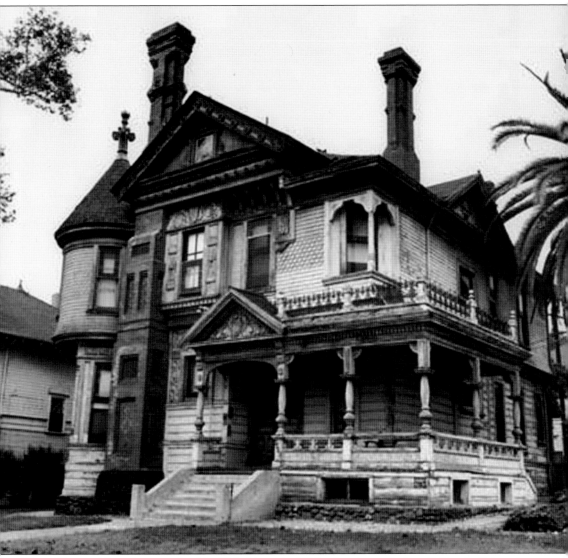

HALE HOUSE. This photograph of the Hale House in 1966, when it was declared Historic Cultural Monument No. 40 by the City of Los Angeles, reveals intricate Victorian detailing. Although the *Los Angeles Times* indicates its designer was W. R. Norton, architect of both Wyngate in South Pasadena and the Boyle Hotel, some believe it was really Joseph Cather Newsom, who was working in Los Angeles at the time and designed some structures in Garvanza. Here the house is on its second site before moving to Heritage Square to make way for a gas station. The adjacent house to the left was demolished. (Photograph by William Reagh.)

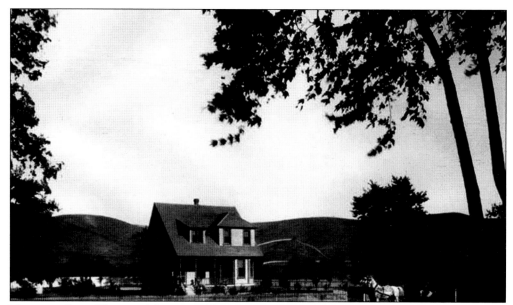

NATHAN COLE HOUSE. A horse and buggy waits on Pasadena Avenue in front of the house around 1890. A few years later, Cole subdivided his land, located adjacent to Sycamore Grove Park, and moved the house to the rear of the new tract, where it remains today. (Security Pacific Collection, Los Angeles Public Library.)

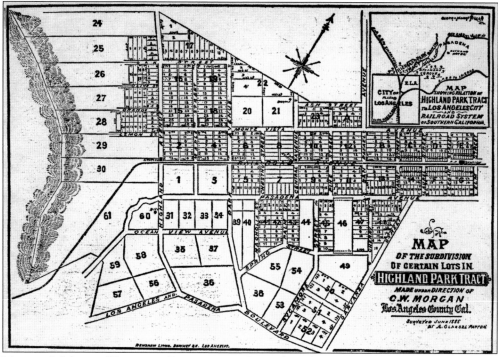

MORGAN'S MAP OF HIGHLAND PARK, 1886. This early real estate map of Highland Park shows the tract after Judson and Morgan split their land holdings. Morgan quickly subdivided his holdings into town lots. Only Monte Vista and Ash Streets retain their original names. (Virginia Neely collection.)

Two

BUST AND RECOVERY

The Southern California land boom collapsed in 1888. Many of the great speculative subdivisions were bankrupt as sales slowed to a trickle. But Highland Park struggled on. The area had a few homes and a school, not to mention the railroad, which made it accessible to the world. Morgan built two houses in the area; Judson eventually followed and built two as well. Both of Morgan's survive. Both of Judson's have been lost.

Highland Park's early growth was outpaced by neighboring Garvanza. The Garvanza Land Company, headed by Ralph Rogers, subdivided that town at the same time. The competing tracts soon caused tension. Judson and Morgan had successfully blocked a street rail project to Garvanza by refusing to grant Rogers a right-of-way. They also sparred in litigation over water rights.

Land sales were slowly increasing. In 1895, Highland Park was annexed to the City of Los Angeles to acquire water rights. There was also the issue of police and fire protection. Sycamore Grove had become a rough area of gambling and prostitution, and the good citizens of Highland Park were not happy. The day after the annexation vote, the questionable businesses burned. The area became a park, which it remains today.

Highland Park was now established as a suburb of Los Angeles, but it would retain its identity—especially after the arrival of Charles F. Lummis in 1896.

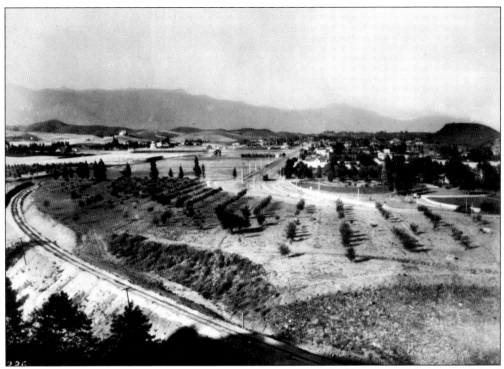

VIEW FROM THE SOUTH, 1895. By the mid-1890s, construction had begun to pick up in Highland Park. This view, from the year the community was annexed to the City of Los Angeles, shows Monte Vista and Pasadena Avenues heading out from the future site of Occidental College. The Monte Vista Street School can be seen in the distance. (C. C. Pierce collection.)

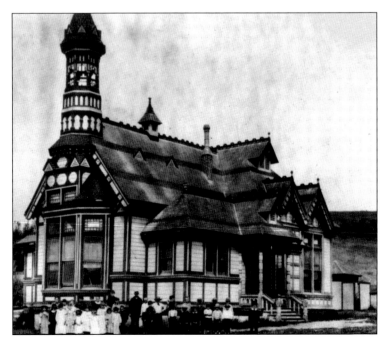

FIRST MONTE VISTA STREET SCHOOL, 1887. Children and their teacher pose in front of the first school building in Highland Park. The whimsical structure, replaced in 1903, moved a block up the street, where it survived as a private home (minus its tower) until the 1940s. (Security Pacific Collection, Los Angeles Public Library.)

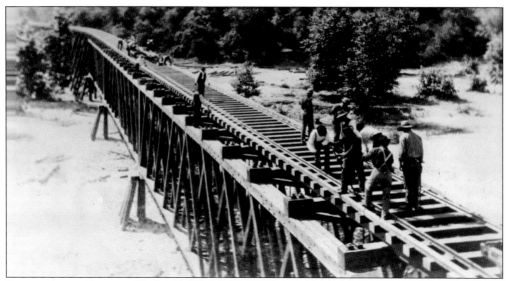

BUILDING THE BRIDGE. Workers labor on the Los Angeles and San Gabriel Railroad Bridge over the Arroyo Seco in 1885. The road was soon purchased by the Atchison, Topeka, and Santa Fe Railroad, becoming a final link in the second transcontinental railroad to reach Los Angeles. (Virginia Neely collection.)

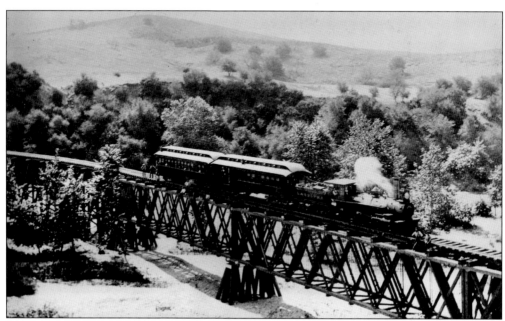

FIRST TRAIN ON BRIDGE. In early 1886, workers pose with one of the first trains to cross the newly completed Arroyo Seco bridge at the present location of Avenue 64 over the Pasadena Freeway. (Author's collection.)

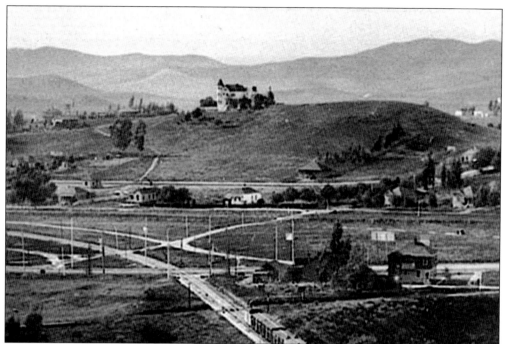

EL MIO ON A HILLTOP, 1896. After he moved to Los Angeles from Santa Barbara to preside over Louise Perkins's 1886 breach of promise lawsuit against Elias J. "Lucky" Baldwin, superior court judge David P. Hatch commissioned the construction of this 1887 Victorian mansion. Hatch was brought in because all the local judges were either friends or foes of Baldwin. (Author's collection.)

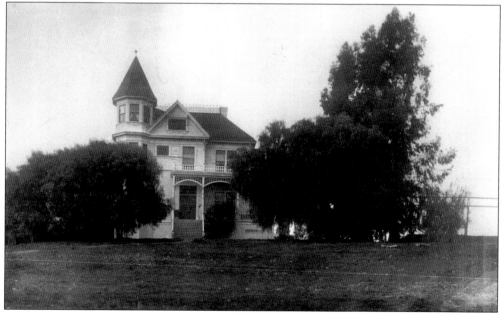

EL MIO IN ITS ORIGINAL SETTING. The hilltop location of the house was later subdivided, and the setting now looks quite different from this 1890s photograph. The home is Los Angeles Historic Cultural Monument No. 142 and is individually listed on the National Register of Historic Places. (Tim Parker collection.)

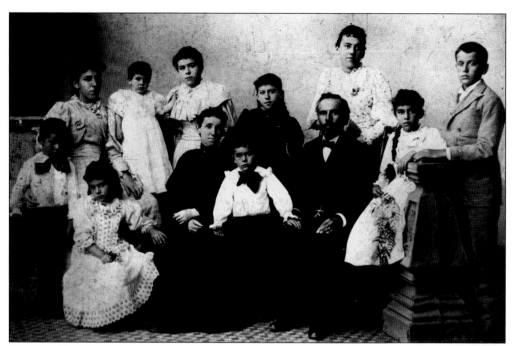

GANAHL FAMILY, C. 1893. Francis Ganahl and his wife, Louise, pose with the first 10 of their 11 children in this formal portrait. Ganahl and his brothers ran a chain of lumberyards in Los Angeles during the late 19th and early 20th centuries. Originally from Austria, the Ganahls came to Highland Park after many years in St. Louis. (Security Pacific Collection, Los Angeles Public Library.)

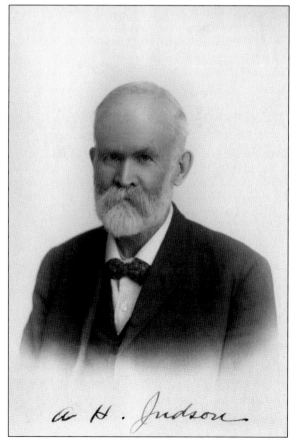

ALBERT H. JUDSON. A. H. Judson, who along with George W. Morgan subdivided Highland Park, was born in Chautauqua County, New York, settling in Los Angeles in 1876 as a lawyer. He founded the L. A. Abstract Company, the first locally to issue certificates of title on real estate. The company later merged with another to form the Title Insurance and Trust Corporation. (Ingersoll Collection, Los Angeles Public Library.)

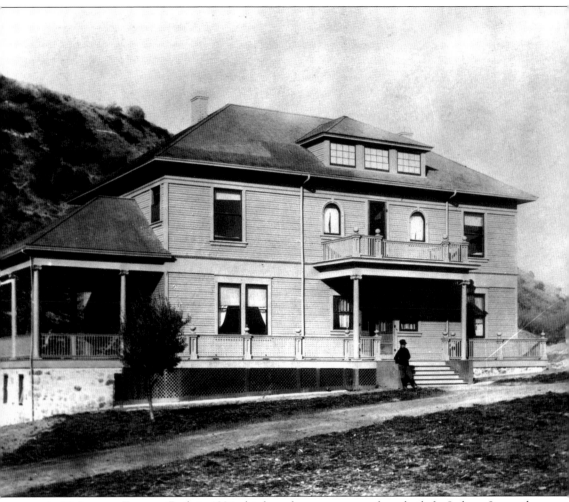

A. H. JUDSON ESTATE. Built in 1894, this large house was one of two built for Judson. It was the family home. In spite of being declared Los Angeles City Historic Cultural Monument No. 437, the George H. Wyman–designed residence was demolished in 1993 and the property remains a vacant lot. Wyman also designed the famous Bradbury Building in downtown Los Angeles. (Author's collection.)

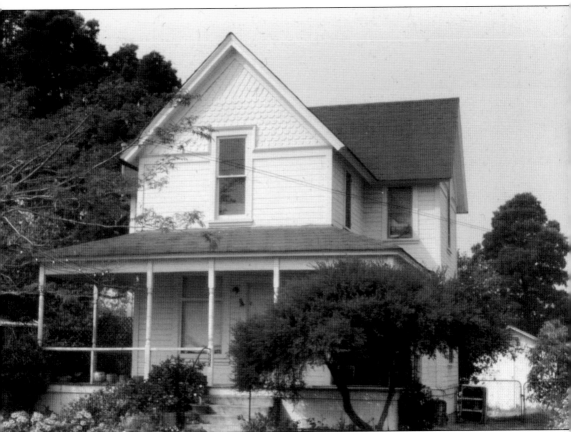

THE DRAKE HOUSE. The Drake House was constructed on Gilbert Street (now South Avenue 60) in 1892. It is a classic example of a homestead house with a tri-gabled el design. Virtually unaltered since being built, it was declared Los Angeles Historic Cultural Monument No. 338 in 1988. (Photograph by the author.)

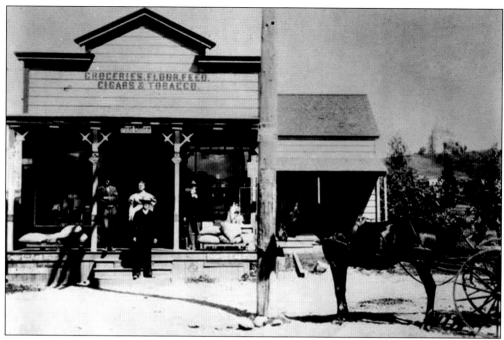

J. P. STOCKDALE'S STORE. This little general store was the first to open in what would become the main Pasadena Avenue shopping district. Stockdale established the business in 1891, and the following year, it started housing the first Highland Park Post Office. El Mio is visible on the hilltop in the background. (Security Pacific Collection, Los Angeles Public Library.)

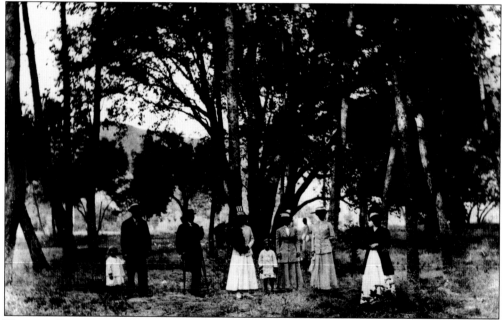

HOLIDAY GATHERING AT SYCAMORE GROVE. This group is likely celebrating the Fourth of July around 1896, after Sycamore Grove was purged of all the seedy businesses that had made it an area where proper people did not go. By this time, the successful effort was well underway to have the area designated a city park. (Virginia Neely collection.)

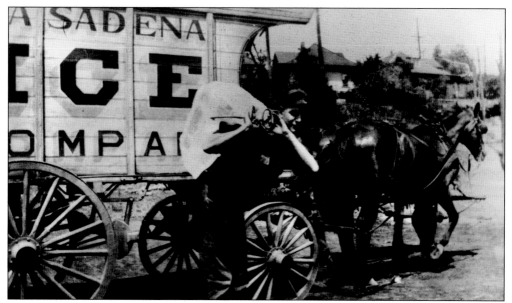

The Ice Man Cometh. As more housing was built, various companies began delivery service in the area. Here the ice man makes a delivery to a location on Longfellow Street near Avenue 56. Block ice was actually available in the area well into the 1970s, when an ice machine was still dispensing it at York and Outlook. (Los Angeles City Historical Society.)

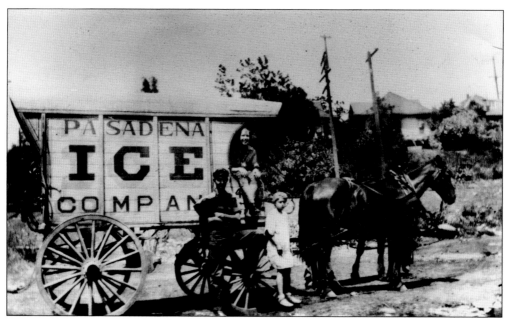

Ice Man and Family. This photograph, taken at the same location as the previous, possibly shows the ice man with his family, indicating that the delivery may have been to his own home. The two images date to about 1903, the year that the houses in the background were constructed. (Los Angeles City Historical Society.)

SYCAMORE GROVE PARK, C. 1900. This view of Sycamore Grove shows the many sycamore trees from which it derives its name, as well as a pond produced as a part of the North Fork of the Arroyo Seco as it nears the main stream. The pond has been gone since the city placed the stream underground for flood-control purposes in the 1930s. (Photograph by Harry Vroman.)

NEW YORK VALLEY. This peaceful valley was in county territory at the time of the *c.* 1900 photograph. The road going up the hill is today's Avenue 51. York Boulevard, then known as Eureka Street, is one of the roads crossing the center. It would soon be renamed New York Avenue. The valley's name was changed to York Valley in the 1920s. (Author's collection.)

Three

THEN CAME LUMMIS

Charles Fletcher Lummis was the son of a Massachusetts preacher. After attending Harvard, he edited a newspaper in Ohio until he met Harrison Grey Otis, founder of the *Los Angeles Times*. Lummis agreed to walk to Los Angeles and send dispatches describing his trip. His column, "Tramp Tramp Tramp," started him on a journey that would change the direction of history.

The trip made Charles Lummis a champion of the rights of Native Americans. He formed friendships with those his met along the way, including Amado Chaves, who would become the first congressman for the state of New Mexico. When Lummis arrived in Los Angeles, Otis appointed him city editor for the young newspaper. Republicans and idealists had a lot in common, but Lummis would count among his many friends people of all political stripes. The same went for his foes as well.

Lummis was always active. In 1896, he formed the California Landmarks Club, the first historic preservation organization on the West Coast, in order to restore and properly preserve the California missions. Two of the region's best architects—Arthur B. Benton (future designer of the Mission Inn in Riverside) and Sumner P. Hunt (future designer of the Southwest Museum)—came on board as restoration architects. Hunt also began working with Lummis on his home, El Alisal ("the Sycamore"), in Highland Park. Lummis's goals were to preserve the history and culture of both the Native American and Spanish heritage of the Southwest. His founding of the Southwest Society in 1903 and the creation of the Southwest Museum would bring the first goal to fruition.

Meanwhile, Highland Park embarked on the building boom that would forever transform the quiet hills of the Arroyo Seco and would bring, for a time, Occidental College to Pasadena Avenue.

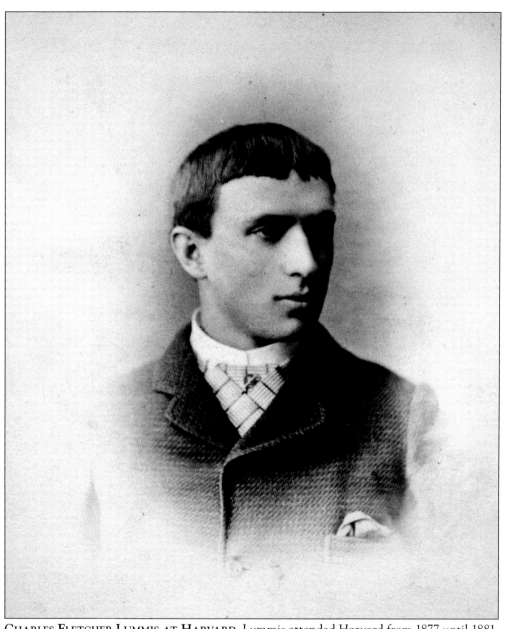

CHARLES FLETCHER LUMMIS AT HARVARD. Lummis attended Harvard from 1877 until 1881. He failed to graduate, however, as he spent much of his time doing things other than studying. At only a bit over five feet tall, he worked to make up for his height handicap by excelling at athletics, especially boxing. Even though he did not finish his senior year because of one missed test, Lummis acquired a first-rate education, as well as lifelong friends such as Theodore Roosevelt. Although they had little background in common, both men had overcome adversity as children and would be workaholics throughout life. In 1880, while a junior at the university, Lummis secretly married a Boston medical student named Mary Dorothea "Dolly" Rhodes, who was the first of three wives. A daughter named Bertha, the result of an earlier affair, became a part of his life in later years. All of his marriages ended in divorce. (Southwest Museum collection, P32523B.)

BIRCH BARK POEMS.
Lummis paid for his Harvard education through odd jobs and his writings. Always a poet, he compiled some of his best works into this volume, which he printed himself on thin birch bark pages. It made enough to pay for most of his time there. He would later write over 30 books and edit newspapers and magazines. He was also an insatiable letter writer. Today his writings are highly sought after and a number have been republished in recent years. (Author's collection.)

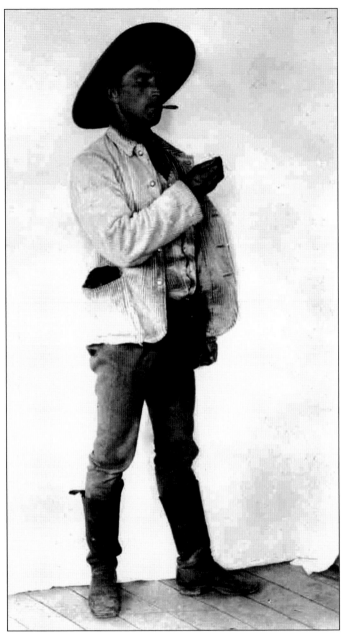

ROLLING A CIGARETTE. In 1887, when he was 27, Lummis suffered a stroke while working 18-to-20-hour days as city editor of the *Los Angeles Times*. His wife, Dorothea, a doctor, said he would never walk again unassisted. He went back to Amado Chaves's ranch in New Mexico and proved the experts wrong. Here he lights a freshly rolled cigarette with his good right hand. While recovering from the stroke, Lummis was shot after photographing and publishing the exploits of the Penitente Brotherhood, who practiced a ritual crucifixion ceremony. He recovered from that as well, returning to Los Angeles married to Eve (Eva) Rea, the schoolteacher at the Isleta Pueblo. The divorce from his first wife, who was unable to have children, was amicable, and Dorothea and Eva became lifelong friends. Eva had four children. Lummis wrote a book describing his recovery through sheer willpower, titling it *My Friend Will*. (Southwest Museum collection, N10276.)

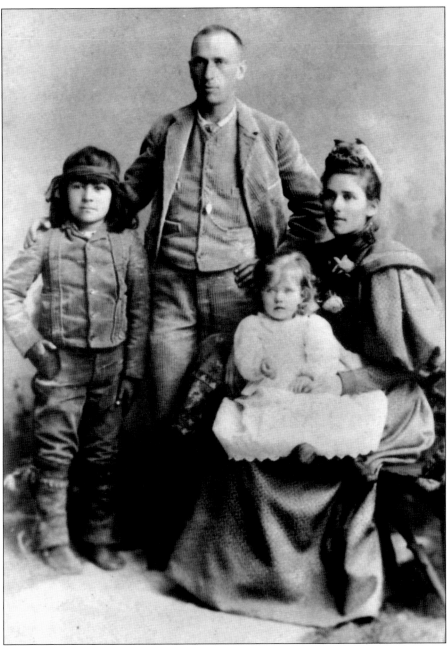

LUMMIS FAMILY PORTRAIT, 1893. Lummis is shown here with his new wife, Eva, and his daughter Turbese. With them is Luis Abieta, one of several boys from the Isleta Pueblo in New Mexico that Lummis had freed from the Albuquerque Indian School, where they were kept away from their families as part of the plan to eliminate Native American ways. Lummis fought the separation and won in court. The government ultimately abandoned the practice, which was Lummis's goal. Luis's mother had named Turbese, meaning "Sun Halo." Three sons would follow, each named after friends of Lummis: Amado Bandelier, for Amado Chaves and archeologist Adolf Bandelier, who had taught Lummis his trade; Jordan Quimu, for David Starr Jordan, the president of Stanford University; and Keith, for artist William Keith. (Southwest Museum collection, N22203.)

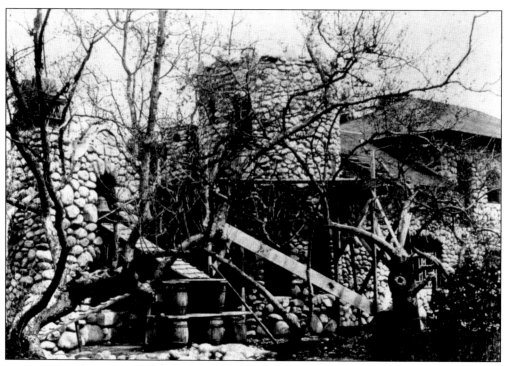

LUMMIS BUILDS HIS CASTLE.
By 1896, Lummis had purchased several lots in the Sycamore Grove Tract. In 1898, he began building his stone castle. Some historians state that the home was designed and built by Lummis; however, a 1900 permit lists Eisen and Hunt as architects. It appears he used Hunt's plans to construct his home with the aid of boys from the Isleta Pueblo and everyone who visited him. (Security Pacific Collection, Los Angeles Public Library.)

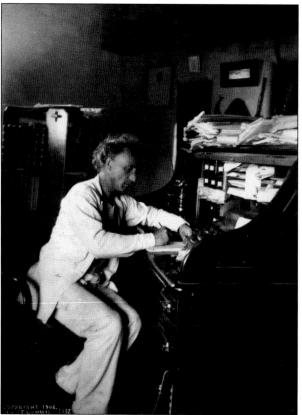

LUMMIS AT HIS DESK, EL ALISAL.
Lummis works on one of his many writings in 1902. Serving as the Los Angeles city librarian for five years, he turned that institution into a world-class enterprise. He also edited a magazine called the *Land of Sunshine*, which published essays by many great writers of the day. (Southwest Museum collection, P32603.)

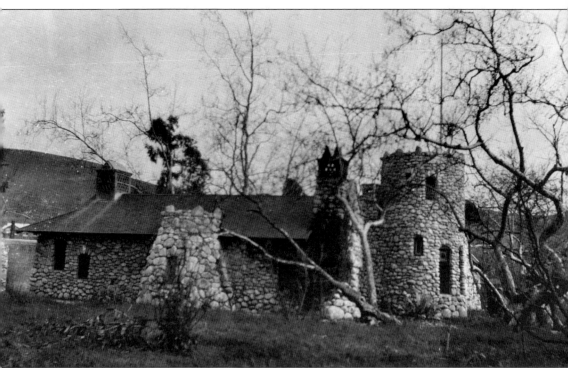

EL ALISAL IN WINTER. This early view of the Lummis Home's west facade was taken during the first decade of its existence. Lummis never really finished its construction. Six-year-old Amado died of pneumonia on Christmas Day in 1900, leaving Lummis devastated. Lummis confided his grief to readers of the *Land of Sunshine* in his monthly column, "The Lion's Den." He also ordered the large south-facing main doors to be closed, and they were never opened again during his lifetime. His infant son, Jordan, also had the disease but recovered. Lummis always worried that "Quimo," as he usually called him, would do something dangerous to himself. In the early 1990s, Jordan's wife was diagnosed with terminal cancer. They ended their lives in a suicide pact, fulfilling his father's prediction. (Virginia Neely collection.)

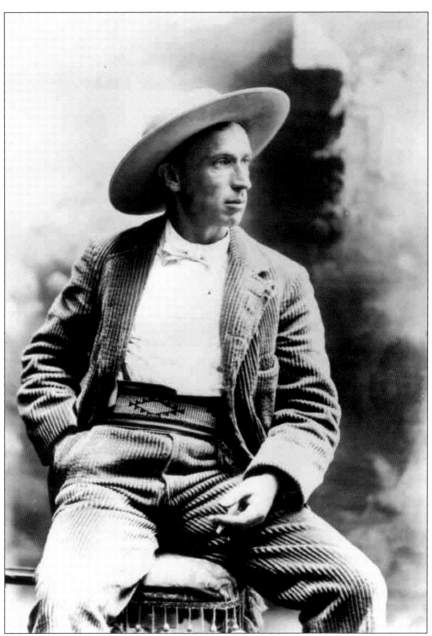

HIS STANDARD OUTFIT. Lummis normally donned this green corduroy suit and well-worn sombrero when he went out. He also wore a red sash in the Spanish style. Lummis was never a conventional dresser. While building his home, he frequently wore thin shirts and shorts, prompting some to accuse him of being immodest. Lummis was ahead of his time in many ways, but also rooted in the history that he set out to tell the world. He never let criticism get to him. If someone had a problem, he wanted to know. There is no question Lummis was an iconoclast; if he had not been one, he would not have accomplished so much in just 69 years. Many years later, Dudley Gordon would wear the same green suit as he lectured about his biography of Lummis, *Crusader in Corduroy*. Gordon served as Lummis Home curator for many years. (Southwest Museum collection, N42477.)

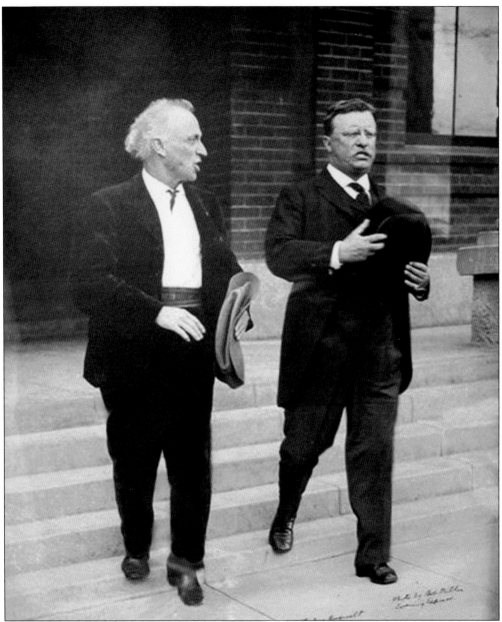

LUMMIS AND ROOSEVELT AT OCCIDENTAL COLLEGE. Theodore Roosevelt listened to Lummis on the affairs of the Native Americans and, with Lummis's urging, began to roll back decades of bad policy at the Bureau of Indian Affairs. Lummis had fought for years to end the bureau's practices and in doing so had made many enemies in the department, but the fight forced change that still resonates today. Roosevelt visited with Lummis several times. Once during Roosevelt's presidency, Lummis secretly arranged for his friend to drive the locomotive of the train by which they were traveling—much to the chagrin of the Secret Service detail that the two men evaded. On March 22, 1911, the former president came to Occidental College to speak. Lummis was his constant companion until he hopped the train for Northern California. (Lummis Home photograph.)

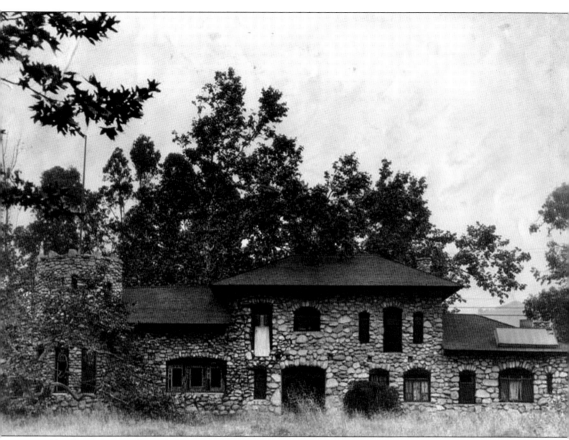

EL ALISAL, THE LATER YEARS. Charles Lummis died of cancer on November 25, 1928. He left an indelible imprint on the nation as well as on Highland Park. His greatest triumph was the establishment and building of the Southwest Museum, the first true museum in Los Angeles and the first major institution anywhere to celebrate the history and culture of Native Americans. Lummis intended to run the museum for the rest of his life but was pushed out by others, who found it hard to deal with his dictatorial style. The home was deeded to the State of California, but it was never really maintained until the Historical Society of Southern California moved in. It was then deeded to the City of Los Angeles, which declared it Historic Cultural Monument No. 68. Also California State Monument No. 531, it is listed on the National Register of Historic Places. This photograph was taken on November 7, 1949. (*Herald Examiner* Collection, Los Angeles Public Library.)

Four

COMING OF AGE

As Lummis was getting started on his home, another event profoundly impacted the Highlands: Occidental College, which had been in Boyle Heights since its founding in 1887, was gutted by an early-morning fire on January 13, 1896. By the end of the year, the Presbyterian school had made the decision to rebuild on a seven-and-a-half-acre site in Highland Park, rejecting sites in Garvanza, Glendale, and Inglewood. By 1898, the college had its first building. Two more major buildings would come, along with minor ones, before the campus outgrew the site and moved to the edge of Eagle Rock in 1914.

By the end of 1906, Pasadena Avenue had been paved and the first full-service bank had formed in the community. The street also had the Pacific Electric, which had acquired a line built by Sherman and Clark in 1895. Pasadena Avenue, which had been built up with mostly large homes by then, was now turning commercial.

This growth brought about the creation of the Greater Highland Park Association in 1922. The organization included all of the small communities surrounding Highland Park in order to produce a united front at city hall. The names of Annandale, Hermon, Sycamore Grove, and York Valley were soon incorporated into Highland Park. Garvanza was involved with the effort as well, and soon it was scooped into the larger community. While the names of Garvanza and Hermon have officially been brought back, the other three remain as part of Greater Highland Park.

By the end of the 1920s, Highland Park was booming with four banks, department stores, markets, and numerous churches. Occidental College stood at its northwest corner, while the Southwest Museum occupied a hill overlooking the entire Arroyo Seco Valley.

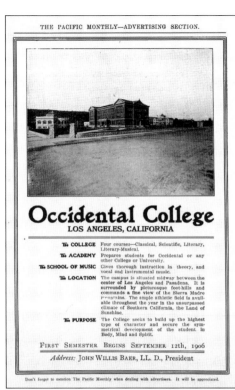

OCCIDENTAL COLLEGE ADVERTISEMENT. This 1906 advertisement in the *Pacific Monthly* shows the three major buildings of the Highland Park campus of Occidental College. Originally established through the Presbyterian Church, the institution would evolve into one of the major liberal arts schools in the western United States. At this time, the school also included an academy to prepare younger students for college. Highland Park did not have a public high school until Benjamin Franklin High opened in 1916. Many of the high school–age students in the area attended the Occidental Academy. Occidental was one of the first colleges in the area to become coeducational. A move in 1912 unsuccessfully tried to reverse that decision. Students were not supposed to get married while attending, though some, such as Millard and Catherine Mier, secretly did just that. No longer officially tied with the Presbyterian Church, Occidental is nonsectarian. (Virginia Neely collection.)

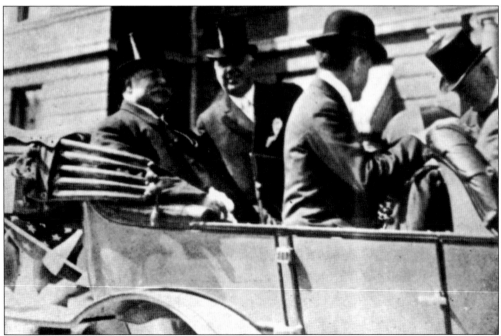

PRESIDENT TAFT ARRIVES AT OCCIDENTAL. Pres. William Howard Taft arrives at Occidental College to give a speech on October 16, 1911. Occidental president John Willis Baer had previously met with Taft in Washington, and this speech was one of several given at various venues that day. (*The Five Friendly Valleys.*)

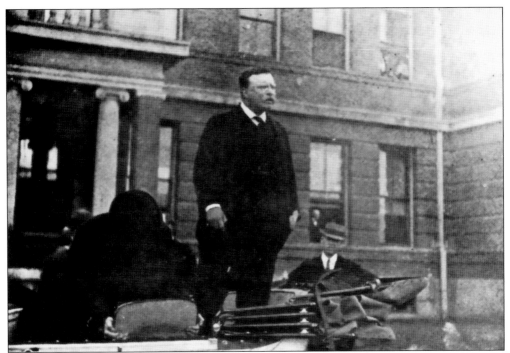

THEODORE ROOSEVELT AT OCCIDENTAL. The former president had just emerged from the Hall of Letters and was ready to leave when the crowd prevailed upon him to give yet another speech. Roosevelt did so from the back of his car, to rousing applause. The following year, he ran against Taft, his handpicked successor, as a Progressive. (*The Five Friendly Valleys.*)

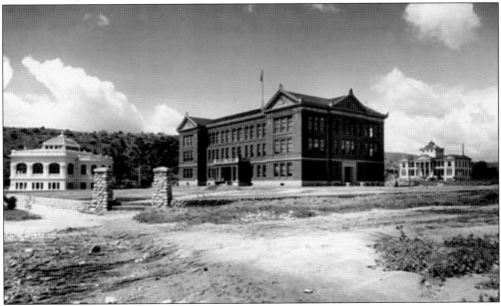

OCCIDENTAL COLLEGE, 1905. This photograph was taken shortly after the completion of the Stimson Library, seen at left. It shows all three of the main buildings of the Highland Park campus. The unpaved streets at the corner of Pasadena Avenue and Avenue 51 are also visible. Though the landscape seems pretty open, the college was now out of room to grow. (Putnam Studios.)

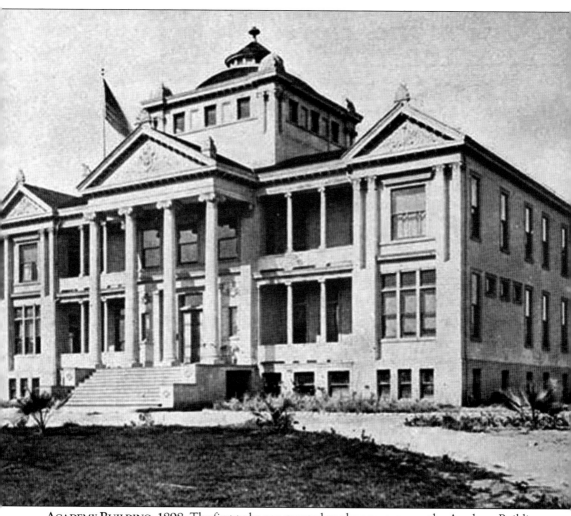

ACADEMY BUILDING, 1898. The first to be constructed on the new campus, the Academy Building was designed by L. B. Valk and Son and housed both classrooms and administration. Other smaller buildings were erected, but it was six years before the school managed to get enough money to build the next major structure. (Security Pacific Collection, Los Angeles Public Library.)

HALL OF LETTERS, 1904. The largest of the three, this brick building was designed by Dennis and Farwell. Minus the top floor, it became the Savoy Apartments. Along with an 1898 science lab, it is the only surviving structure from the campus. The building was declared Historic Cultural Monument No. 484 by the City of Los Angeles in 1991. (Security Pacific Collection, Los Angeles Public Library.)

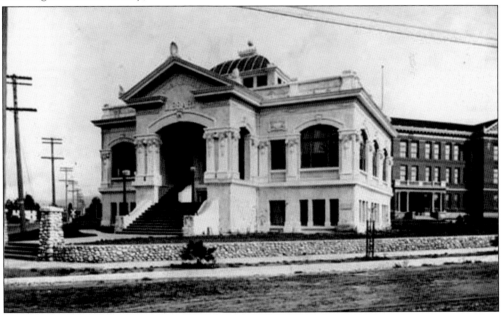

CHARLES M. STIMSON LIBRARY, 1905. When first built, this ornate structure also served as the pubic library for several years until the college needed the space. After Occidental moved to Eagle Rock, a chiropractic college attempted to move in. That venture failed, and the building was demolished in 1929 to make way for Angelus Chevrolet. (Security Pacific Collection, Los Angeles Public Library.)

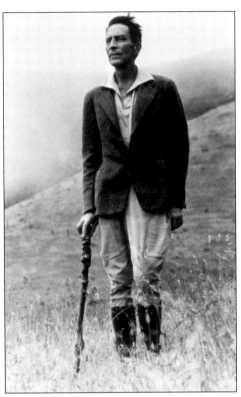

ROBINSON JEFFERS. Renowned poet-playwright Robinson Jeffers was a noted graduate of the Highland Park campus. He later moved to Carmel, where this photograph was taken, built his famous Tor House, and resided there the rest of his life. There are many interesting connections between Highland Park and the Monterey area, mainly because of Jeffers's friend Charles Lummis. (Highland Park Heritage Trust.)

HIGHLAND PARK PRESBYTERIAN CHURCH, 1903. This nice Mission Revival church, which stood on the corner of Pasadena Avenue and Avenue 53, was designed by Highland Park architect Thornton Fitzhugh. As the congregation grew, the building gave way to a larger brick-faced sanctuary designed by George Lindsey in 1923. (Virginia Neely collection.)

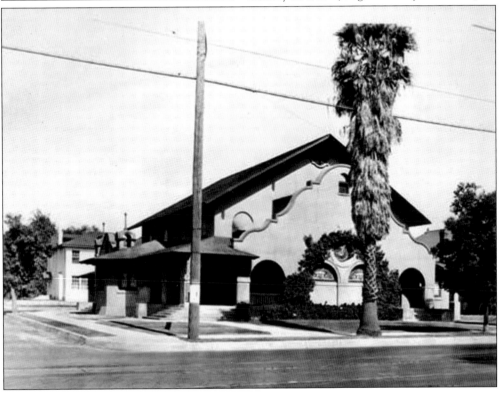

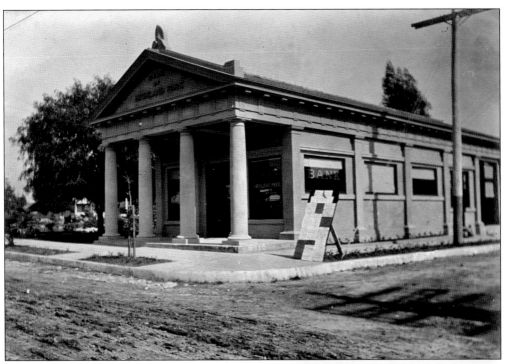

HIGHLAND PARK BANK, 1906. Housing the first bank in Highland Park, this classical building was also designed by Thornton Fitzhugh. The bank opened it doors on March 10, 1906, with a rush of customers. This photograph, one of the earliest of the building, shows the muddy, unpaved streets. That would change by the end of the year. (Author's collection.)

GEORGE WASHINGTON EWING GRIFFITH. G. W. E. Griffith was a Midwestern banker who came to Highland Park to retire. He built his house on Pasadena Avenue and decided to reenter the banking business, opening a bank in neighboring South Pasadena as well as the one above in Highland Park. In 1927, Griffith published a colorful autobiography entitled *My 96 Years in the Great West, Indiana, Kansas, and California*. (*The Five Friendly Valleys.*)

43

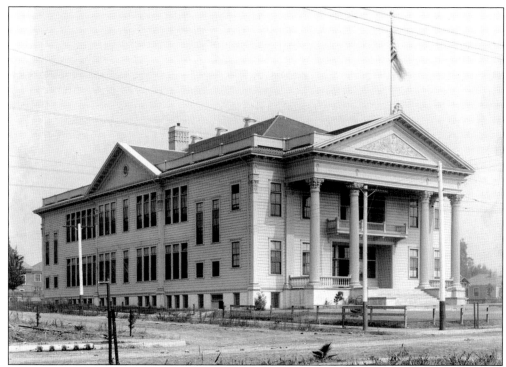

SECOND MONTE VISTA STREET SCHOOL. The whimsical schoolhouse in chapter one was replaced by this classical building in 1903. It would serve as the schoolhouse for the central Highland Park community until being replaced in 1959 by the stucco box structure that remains today. (Security Pacific Collection, Los Angeles Public Library.)

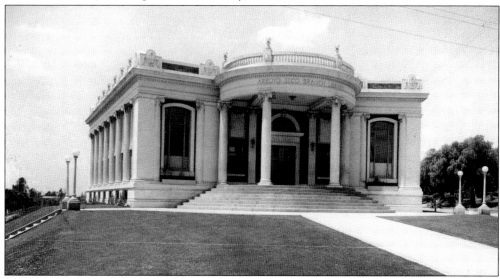

THE ARROYO SECO REGIONAL LIBRARY IN 1914. Built in 1913 with money from the Carnegie Institute, the first city library in Highland Park was designed by Garvanza-area architect Frederick M. Ashley. The attractive building was demolished in 1959. The triangular lot proved a challenge for the architect, as it has for the two subsequent buildings on the site. (Photograph by Leroy Hulbert, Los Angeles Public Library.)

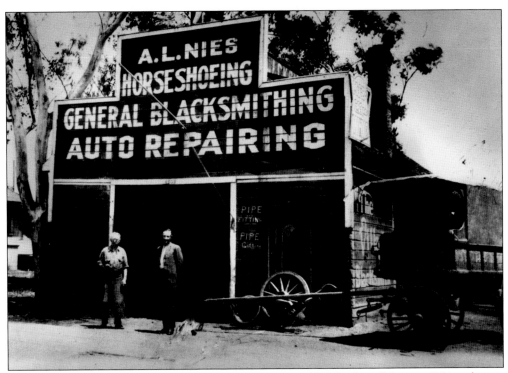

THE BLACKSMITH SHOP OF ALBERT NIES. From 1898 until his death in February 1954 at the age of 81, Al Nies was the "village smithy" in Highland Park, operating this shop at 6100 Pasadena Avenue (later Figueroa Street). In 1912, he modified his business to include auto repair, as pictured, but his first love was always working the anvil and forge. (Virginia Neely collection.)

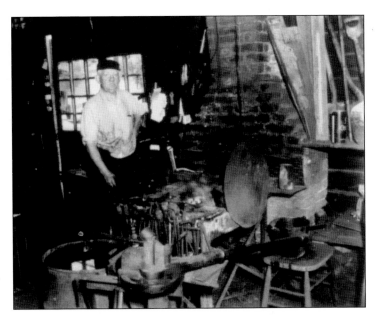

NIES AT WORK, LATE 1940S OR EARLY 1950S. "Albert Lewis Nies wasn't dragged into the 20th century but, once it was here, he wouldn't compromise either," stated Roger Swanson in a 1976 *Highland Park News Herald and Journal* article on the blacksmith. An Iowa native, Nies came to Los Angeles with his parents in 1882. (Virginia Neely collection.)

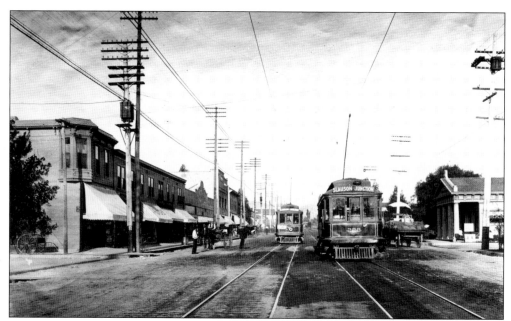

5700 BLOCK OF PASADENA AVENUE. Pacific Electric No. 228 and a southbound car travel along "The Avenue" with wagons in 1906. This photograph reveals a growing business district in Highland Park. Grading has apparently begun on the dirt street, signaling paving in the near future. By the 1920s, most of Pasadena Avenue had turned commercial. (Security First National Bank collection.)

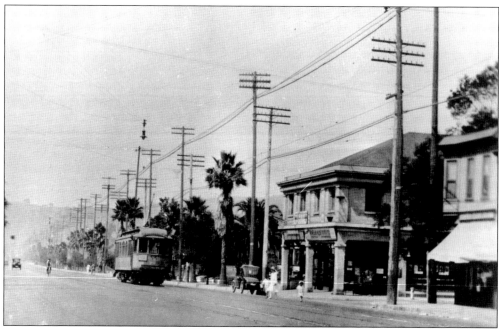

5600 BLOCK OF PASADENA AVENUE. Pacific Electric No. 413 heads south on Pasadena Avenue. This view, taken around 1915, shows paved streets and the palm trees that were planted 20 years earlier. The two-story building to the right is the Highland Park Drug Company. In 1964, the building was "modernized" by removing its second story and making it a stucco box. (Author's collection.)

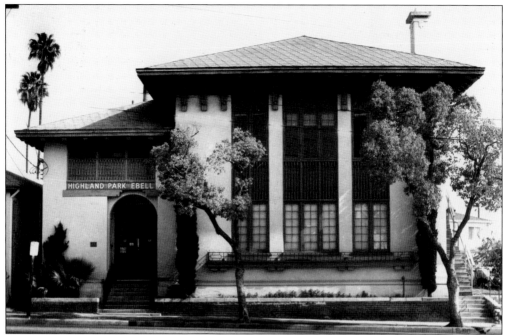

HIGHLAND PARK EBELL CLUBHOUSE. This Prairie-style building has been the home of the local Ebell Club since 1912. Designed by architects Sumner P. Hunt and Silas R. Burns, the structure is listed as Historic Cultural Monument No. 284. An annex (not shown), designed by Sidney Clifton, was built in 1937. (Photograph by the author.)

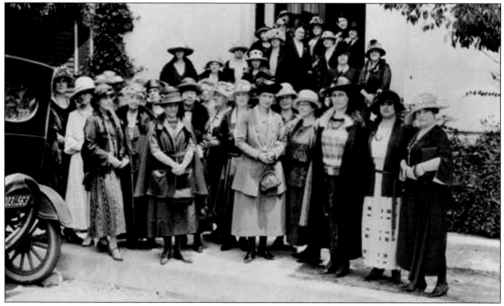

THE EBELL LADIES IN 1923. The women of the Ebell, some of them charter members, pose in front of their clubhouse. Established in 1903, the local club immediately became active in advocating the creation of the Arroyo Seco Park along the stream. Teddy Roosevelt agreed with Lummis in 1911 that the area had to become a park. (Security Pacific Collection, Los Angeles Public Library.)

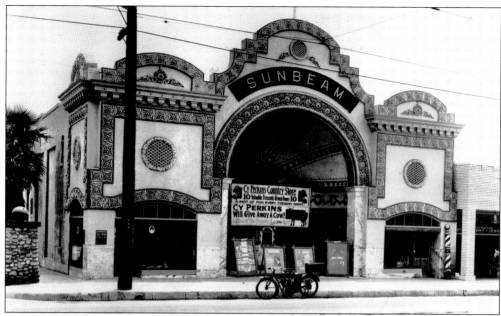

THE SUNBEAM THEATER. Built in 1914, the Sunbeam was designed by architect A. Lawrence Valk. It was closed in 1925 when it was bought by the owners of the new Highland Theater and shut down to eliminate competition. The facade was removed at some point thereafter. For many years, the building housed the offices of the *Highland Park News Herald*. (Virginia Neely collection.)

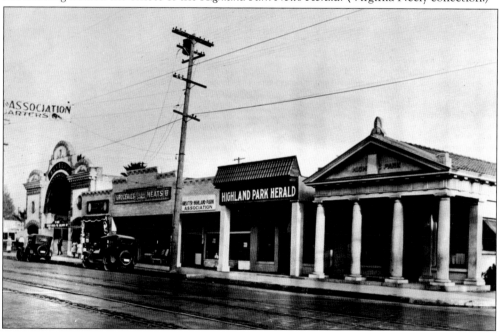

PASADENA AVENUE STOREFRONTS. This 1922 photograph of the 5700 block shows the bank building (far right), the newspaper in the former post office, the G. W. E. Griffith Building, and the Sunbeam Theater (far left). With the exception of the former post office, all of these buildings still exist, though altered. Note the office and street banner for the newly formed Greater Highland Park Association. (Security Pacific Collection, Los Angeles Public Library.)

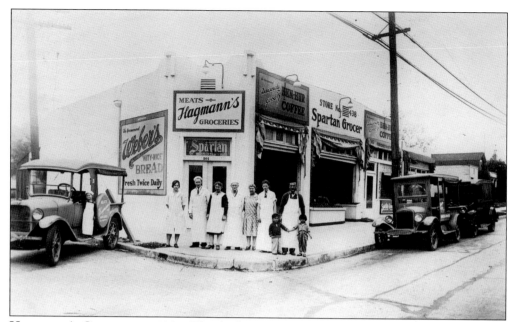

HAGMANN'S GROCERY, C. 1920. This little store, located at 601 Annandale Boulevard, was one of many that dotted Highland Park in the 1920s. The shop was part of the Spartan chain as Store No. 438. As evidenced by the trucks, the business offered delivery of customers' groceries. (Author's collection.)

HAGMANN'S BUILDING, 2007. The address is now 6701 North Figueroa Street. In spite of alterations and tagging, the little store appears to retain most of its original architectural features. While not located in the historic district, the building could be a viable historic storefront again. Many of the historic commercial buildings in the area have gone through similar changes but some have now been restored. (Photograph by the author.)

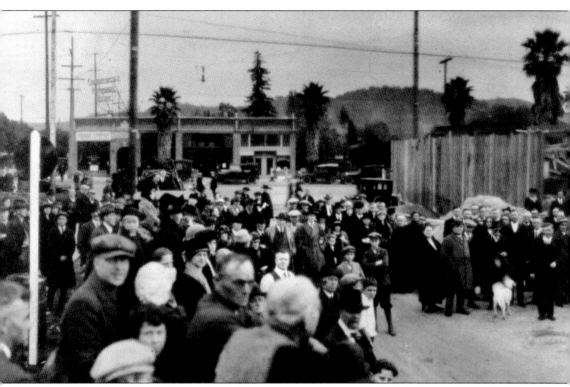

MASONIC TEMPLE CORNERSTONE. Highland Park Masonic Lodge No. 382 was chartered in 1907, but the Lodge building was not completed until 1923. These two images are part of a long panorama that was taken on December 16, 1922, at the laying of the building's cornerstone. The event was presided over by the Most Worshipful William A. Sherman, Grand Master of Masons

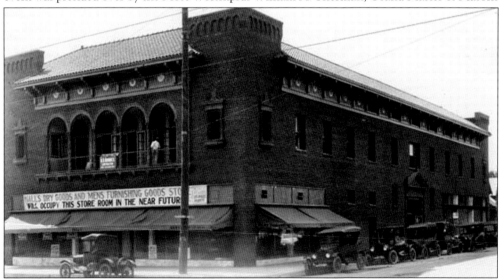

HIGHLAND PARK MASONIC TEMPLE, 1923. Workmen place the final touches on the new Masonic Temple. Architects Elmore R. Jeffrey and Frank Schaffer designed the structure. Jeffrey, who would be Master of the Lodge in 1927, donated the building plans. Halls department store was one of several along Pasadena Avenue. (Security Pacific Collection, Los Angeles Public Library.)

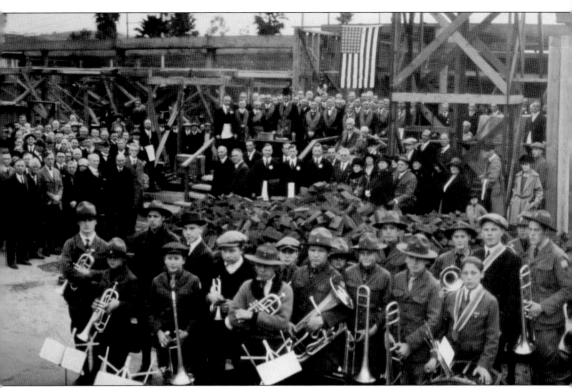

for California and Hawaii. Across the street is the newly completed Commercial National Bank Building. This event, like the one depicted on the cover, brought out community members, who joined the Lodge brothers for the occasion. (Author's collection.)

MASONIC TEMPLE MAIN ENTRANCE.
Dwindling in membership, the Lodge consolidated with Eastgate Lodge No. 290 in Lincoln Heights, forming Fellowship Lodge No. 290 in 1982. It is now a part of South Pasadena Lodge No. 290. The Masonic Temple was declared Historic Cultural Monument No. 282 in 1984 and is also listed on the National Register of Historic Places. (Photograph by the author.)

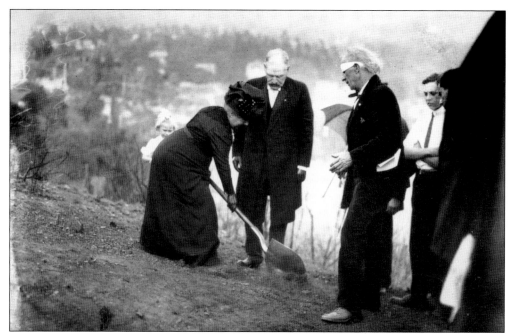

SOUTHWEST MUSEUM GROUNDBREAKING. Elizabeth Benton Fremont, daughter of Gen. John C. Fremont, turns the first dirt for the Southwest Museum on November 16, 1912. Lummis stands to the side with his eyes covered, having been blinded by "jungle fever" at an archeological dig in Guatemala. His sight would return several months later. (Southwest Museum collection, S1-21A.)

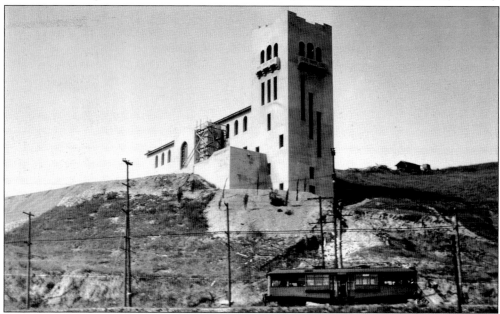

SOUTHWEST MUSEUM NEARS COMPLETION. A trolley passes on Marmion Way while work continues on the building named after Carrie M. Jones. Jones died in 1909 and left the museum a gift of $50,000, providing the building be constructed by 1914. Her estate was not settled until 1927, but attorney Henry O'Melvany, who had arranged for the hilltop site, made sure the money was there. (Southwest Museum collection, S1-189.)

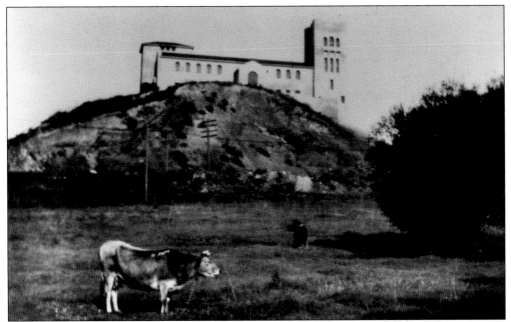

Cow Grazes by Southwest Museum. This bucolic photograph, taken shortly after the museum was completed in 1914, gives an idea how much open space was still in the area at that time. Within a decade, the Woodside Tract would be covered with housing. The cow appears to be at about the location where Casa de Adobe would be built in 1917. (Southwest Museum collection, S1-604.)

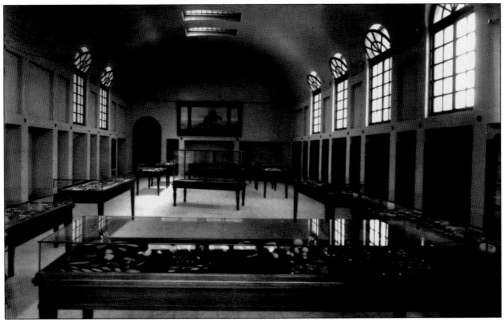

Display Gallery in Southwest Museum. This 1914 Lummis photograph shows the display cases that were used when the museum opened its doors. In this era without air-conditioning, cooling was aided by opening the large transom windows at the top of the gallery. Most museums with large collections can only display a portion at any one time. (Southwest Museum collection, S1-169A.)

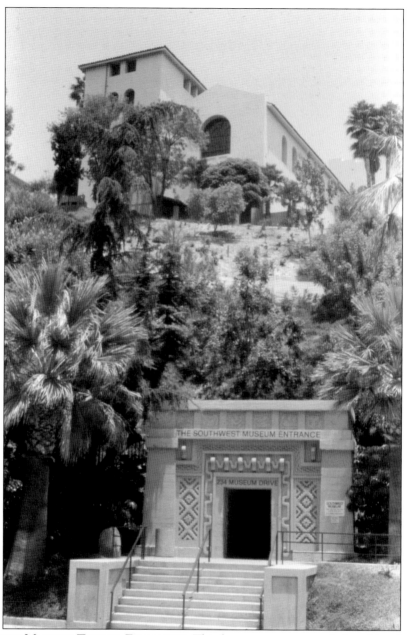

SOUTHWEST MUSEUM TUNNEL ENTRANCE. This lower entrance was designed by the firm of Allison and Allison in the pre-Columbian style to create an easier way of accessing the museum. The tunnel was lined with dioramas depicting the Southwest tribe's villages and lifestyle and ended at an elevator. Completed in 1920, the tunnel began the first phase of expansion plans that were ultimately never completed. The Poole Wing was added in 1940, and the Braun Research Library was built in 1976. A parking lot is also located at the top of the hill. In 2002, the museum merged with the Gene Autry Western Heritage Museum, with the promise that the historic building would be used to display the collection. It is now a part of the Autry National Center. The Southwest Museum was declared Historic Cultural Monument No. 283 on August 29, 1984, and is listed on the National Register of Historic Places. (Photograph by the author.)

Five

THE RAMPAGE
OF THE ARROYO

Home building continued in Highland Park at a furious rate during the first two decades of the 20th century, spurred on by the cadre of real estate developers who believed that growth was not only inevitable but desired by the community.

Tracts were subdivided by Ralph Rogers, G. W. E. Griffith, William B. Judson (Albert's son), Sarah Judson (Albert's wife), Poor and Wing, William Blakeslee, Carl Packard, Elizabeth Young Gordon, John H. Scott, Grider and Hamilton, and numerous others who for the most part lived in the area.

Subdivisions had such colorful names as Hampton Terrace, Highland Heights, Packard's Highland Park Centre Tract, New York Tract, Montezuma Tract, St. Francis Heights, Spring Tract, Mount Angelus, Roselawn Place, Occidental Block, Packard's Arroyo Bluff Tract, Ralph Rogers Mineral Park Tract, Highland Home Tract, Oak Terrace, Glenmary, Woodside, Chautauqua Tract, Glenview, Heights Tract, Highland Park Addition, Arroyo Heights, Annandale Tract, and even Highland Park Electric Tract. By the 1920s, the County of Los Angeles was assigning numbers, such as Tract 4404 for the subdivision around El Mio. Many of the later development names have been lost for that reason.

As Highland Park grew, so did the risk of a natural disaster as building commenced without the necessary precautions. In February 1914, nature struck back. After several days of heavy rain, the Arroyo Seco overflowed and brought about unprecedented destruction in the area. The Highlands banded together even more and fought to make the creek safer. At the sacrifice of the natural creek bed of the Arroyo, a channel was built to contain future floodwaters. The channel was constructed after the Great Depression put the brakes on Highland Parks' growth.

MONTE VISTA STREET, 1905. This image shows the Academy Building for Occidental College (center right) and the second Monte Vista Street School (behind the Academy Building). A comparison with the photograph on page 18 reveals just how much change occurred in 10 years. The tent in the foreground is pitched at about the location of present-day Joy Street. (Security Pacific Collection, Los Angeles Public Library.)

MONTE VISTA AT AVENUE 50, C. 1905. By the time this photograph was taken, the central area of Highland Park was really starting to grow. To the right of Avenue 60, facing Pasadena Avenue, stands the new fire station (see page 68); to the left is a lumberyard warehouse. On the hillside across the Arroyo Seco is the Hermon Free Methodist Seminary, which was established in 1904. The school, later called Pacific Christian High School, closed its doors on the eve of its 100th anniversary. After an initial effort by a home developer to purchase the property, it was bought by another Christian school. (Security Pacific Collection, Los Angeles Public Library.)

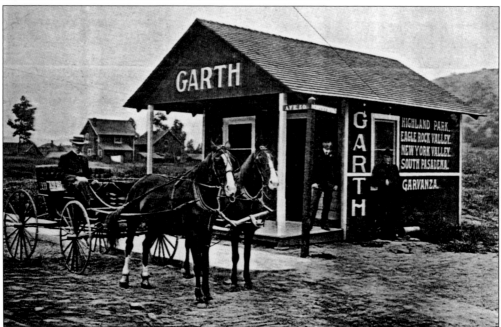

GARTH REAL ESTATE , 1907. One of many small real estate offices in the area, this little structure was built at the corner of Avenue 50 and Monte Vista Street, where a laundromat stands today. The corner is roughly at the center of the previous photograph. The names of the communities served show the former names of Eagle Rock and York Valley. (Virginia Neely collection.)

W. F. Poor Residence. This steep-pitched Craftsman house was built in 1905 for real estate man W. F. Poor. His partner, Sanford Wing, constructed a home nearby. The residence, attributed to architect Paul Van Trees, is now Historic Cultural Monument No. 582. Poor and Wing was an important real estate firm in Highland Park at the time. (Photograph by the author.)

Putnam House. This interesting home was designed by architect George H. Wyman (best known for the Bradbury Building) in 1903 for realtor James G. Cortelyou and later sold to the Putnam family. Of the four Wyman-designed homes in Highland Park, two remain. The house, located on Hayes Avenue, is listed as Historic Cultural Monument No. 375. (Photograph by the author.)

J. J. BACKUS HOUSE. Contractor John J. Backus began this unique shingle-sided house in 1903, finishing the job with the garage in 1930. Backus served as Los Angeles city superintendent of buildings from 1904 until his death in 1937. He designed at least one fire station, No. 26, in 1911. Pictured in 1992, the house would be covered with stucco in 1994. (Photograph by the author.)

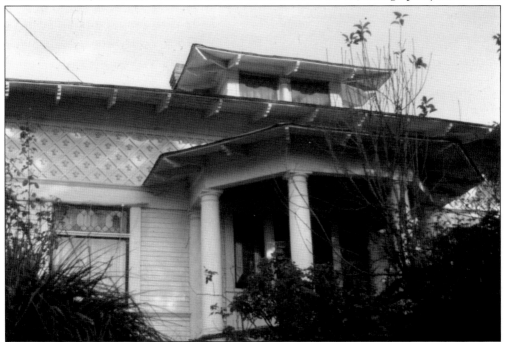

WHEELER-SMITH HOUSE. Edgar Wheeler was the Los Angeles city engineer at the time his Howard and Train–designed home was built in 1897. The residence would remain in the family for four generations. Mary Smith Krilanovich, Wheeler's great-granddaughter, asked the Highland Park Heritage Trust to apply for historic status, and it was declared Historic Cultural Monument No. 378 in 1988. (Photograph by the author.)

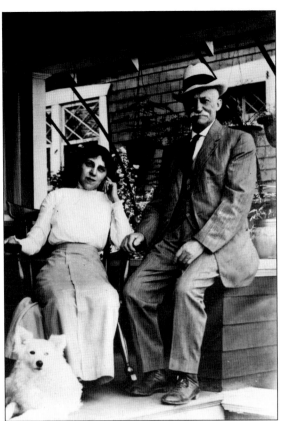

JOHN H. SCOTT AT HOME. Always dignified in appearance, Scott—shown here on his front porch with his wife, Leotta, and the family dog—was one of the most prolific home builders in Highland Park. He used several plans, making Scott Houses some of the easiest to spot in the area. In 1903, he subdivided Roselawn Place and filled it with Craftsman cottages and Dutch Colonials. (Virginia Neely collection.)

SCOTT FAMILY. John Scott (center kneeling) and his extended family pose on the old wooden Hermon Avenue Bridge over the Arroyo Seco around 1910. Scott's stepdaughter is seen at the far left. She would become the mother of Elizabeth Finkbinder, who supplied these family images as well as the photograph of the Sunbeam Theater (see page 48). (Virginia Neely collection.)

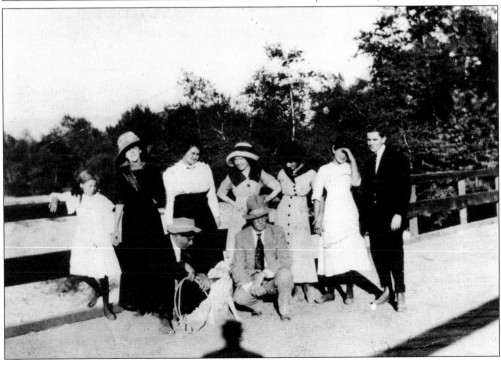

RUDESILL RESIDENCE. This Mission Revival home was designed by architects Norman Foote Marsh and Clarence Russell for William Rudesill in 1904. Rudesill soon became a community activist, working to get area improvements such as stone posts at the front of his street, Avenue 58. The posts were removed years later. (Photograph by the author.)

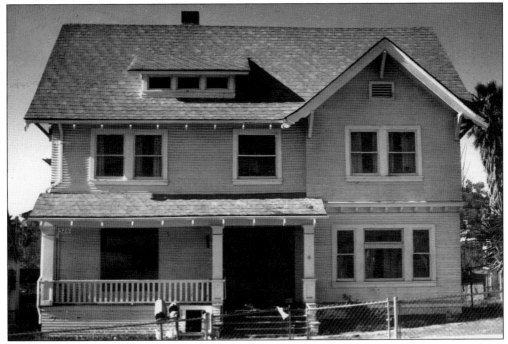

PIPER HOUSE. Built in 1905, this early Craftsman residence is an example of the contractor-built homes being constructed in the area. The house was declared Los Angeles City Historic Cultural Monument No. 540, but was destroyed by fire on the night of August 20, 1995. John Nese of Galcos Soda Pop Stop (see page 126) later moved two historic homes onto the site. (Photograph by the author.)

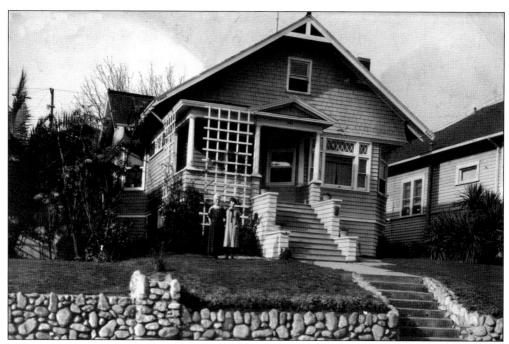

FISHER HOUSE, C. 1920. Lloyd Wiegand Fisher was an architect who worked for several major firms during his career. He designed and built the family home on Piedmont Avenue in 1906. In front of the house are his sister-in-law Elizabeth Fletcher (left) and his daughter Ada, who became a teacher for Los Angeles schools under her married name of Ada Bewsher. (Photograph by Lloyd W. Fisher, author's collection.)

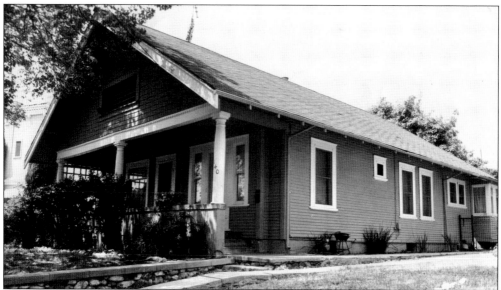

WILLIAM U. SMITH HOUSE. Originally from Pennsylvania, Smith built his house from a set of plans in 1908. He modified the facade to reflect a Greek Revival style remembered from his youth and put himself down on the permit as architect. The house remained in the Smith family until 1977. Now Historic Cultural Monument No. 376, it has been the home of the author since 1982. (Author's collection.)

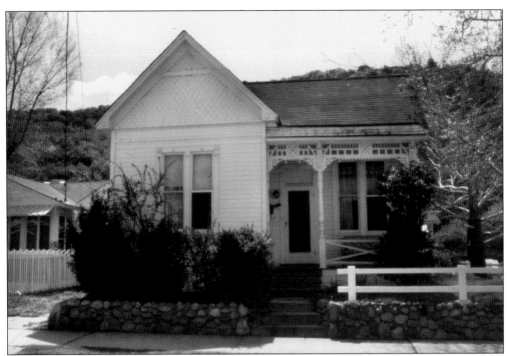

VICTORIAN FARMHOUSE BY THE ARROYO. This house was moved to its current location on what was then Hermon Avenue in 1911. The street is now Via Marisol, named after former councilman Arthur K. Snyder's little girl. At one time, the road was part of Paseodero Monterey, which crossed the Arroyo Seco as one of the Old Spanish Trails. Another section is now part of Monterey Road. (Highland Park Heritage Trust.)

OCCIDENTAL COLLEGE PROFESSOR. John Alexander Gordon waits for the trolley to go downtown in this *c.* 1900 photograph. Behind him is the McCrea residence, home of the grandparents of actor Joel McCrea. Built in 1899, the large Mission Revival residence, known as Glenmary, was destroyed by fire six decades later. Today it is the site of the Arroyo Seco Alternative School. (Virginia Neely collection.)

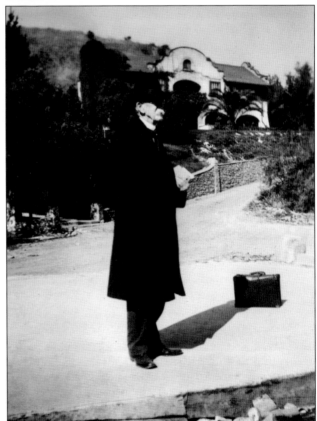

63

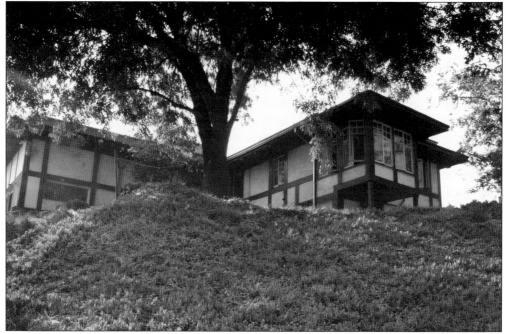

ARTHUR S. BENT HOUSE. This half-timbered residence has Craftsman detailing and a large Bathchelder fireplace. Some experts consider the 1903 Hunt and Egger house to be the earliest example of Modernism in Los Angeles. The Secessionist massing may be the result of an Austrian trip by A. Wesley Egger earlier that year to study that movement. The home is now Historic Cultural Monument No. 482. (Photograph by the author.)

THE ARROYO STONE HOUSE. Built with wood framing and clad in stone, this attractive house was built as a residence for Occidental College instructors by Elizabeth Young Gordon, the wife of John A. Gordon. The street, then named Fredonia and now Sycamore Terrace, became known as "Professors Row." The house is listed as Historic Cultural Monument No. 373. (Photograph by the author.)

BUILDING OF THE ABBEY SAN ENCINO. Jack Browne rests in the future location of the stained-glass window in this construction photograph of the home of his father, Occidental College printer Clyde Browne. The elder Browne viewed his work as art. Jack, a musician, would become the father of the singers Severin and Jackson Browne. (Highland Park Heritage Trust.)

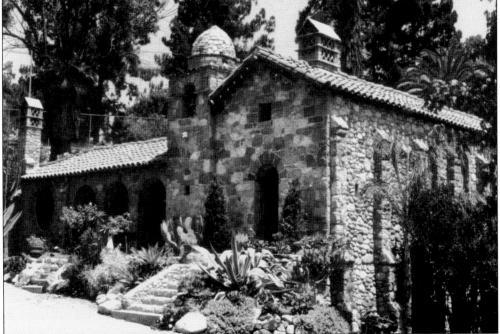

THE ABBEY AS COMPLETED. Clyde Browne originally called his home Oldestane Abbey, and the walls contain bits of abbeys, castles, and other ruins that Occidental College professors brought back from Europe. Browne was a Medievalist as well. The home, remaining in the Browne family, is listed as Historic Cultural Monument No. 106. (Photograph by the author.)

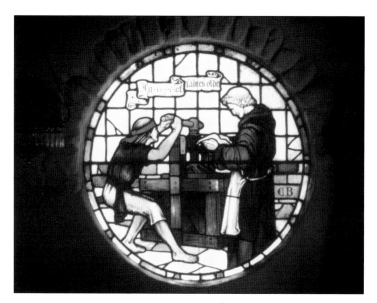

THE ABBEY WINDOW. This window, which illustrates early printing in California, was made by the famed Judson Studios in Garvanza. It illuminates Clyde Browne's print shop, where he performed custom work, printed Occidental College materials, and published the periodical *Abbeygram*. Browne's work is highly prized by collectors today for its unique design and quality. (Photograph by the author.)

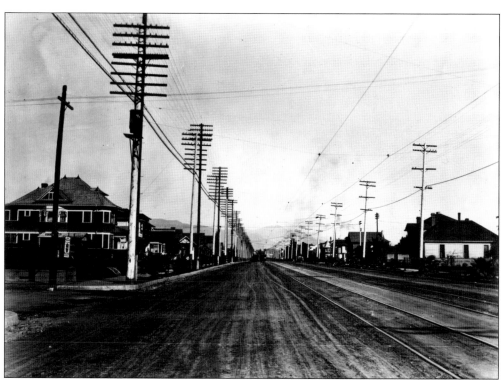

PASADENA AVENUE, 1905. Starting just north of the Occidental College campus, Pasadena Avenue runs straight for the next 10 blocks. In the distance is a Pacific Electric Red Car. This suburban scene would become almost totally commercial within the next 20 years. Many of the homes were moved to side streets. Only the large house to the left remains in place today. (C. C. Pierce collection.)

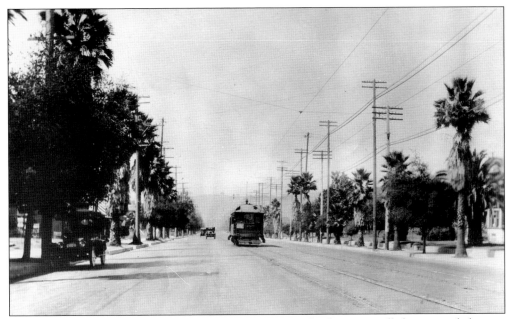

PASADENA AVENUE, 1918. Looking south from Avenue 57, this view still shows mostly homes. The tiny palm trees seen in the previous photograph are now much larger. The survivors today are about 100 feet tall. In the 1970s, this block and others were replanted with fichus trees that soon obscured commercial signs. Those have also been replaced. (Author's collection.)

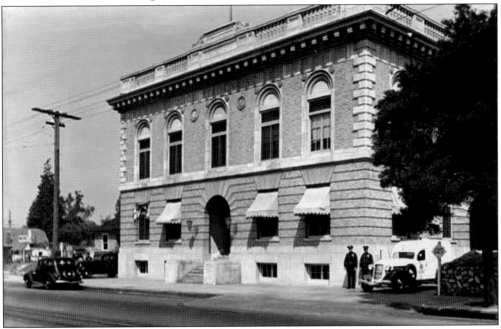

POLICE STATION NO. 11. The City of Los Angeles designed and built the first police station for Highland Park in 1925 (see page 8). The station contained a small jail used for incarcerating minor offenders and for holding others before transporting them downtown. By 1936, when this photograph was taken, there was a receiving hospital to the east. (Security Pacific Collection, Los Angeles Public Library.)

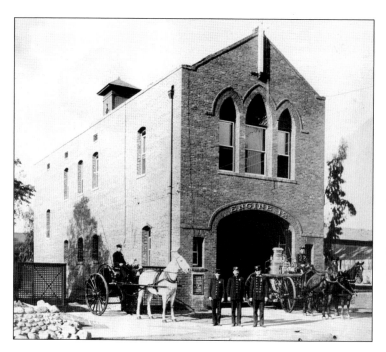

ENGINE COMPANY NO. 12. The Los Angeles City Fire Department erected this brick station in 1903 to serve the Highland Park area. The city had been building new fire stations at a fast pace to keep up with the growth. In the days of horses, this facility was state of the art, with the latest equipment and the best-trained men. (Los Angeles Fire Department Museum.)

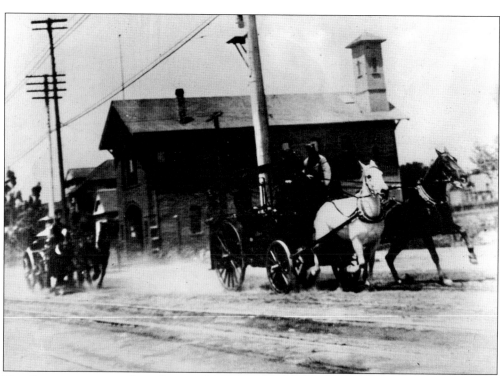

THE EXCITEMENT OF A FIRE ALARM. Men scramble to get to a fire with horses pulling at top speed in this 1909 image. The horses, which were soon replaced by trucks, were trained to gallop fast and many had problems adjusting to the slower speeds of civilian use when they retired. (Northeast Newspapers collection.)

HIGHLAND PARK RECREATION CENTER, 1923. The Community Clubhouse on Piedmont Avenue was the pride of the area, with a full gymnasium, auditorium, bowling alleys, billiard rooms, nurseries, and rooms for community functions—all available without charge. The building was designed by Hunt and Burns in the Craftsman style. (Photograph by Charles W. Beam, *The Five Friendly Valleys.*)

HIGHLAND PARK RECREATION CENTER, 1982. The building awaits the wreckers in this last photograph of the old clubhouse. Many argued over its future, and a last-ditch Historic Cultural Monument application failed. The new building is a sterile utilitarian box with only some of amenities of the original. There is no large, friendly fireplace either. (Photograph by the author.)

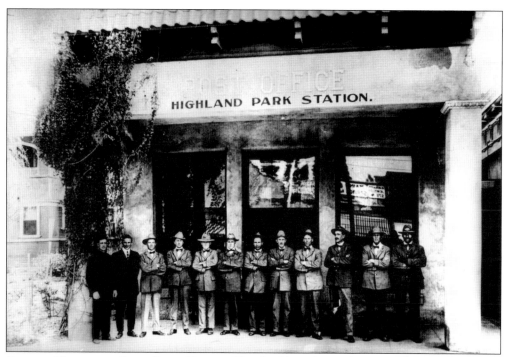

SECOND HIGHLAND PARK POST OFFICE. This building, located next to the Highland Park Bank, housed the first full-service post office following 14 years in Stockdale's Store (see page 24). The facility was used from 1906 until 1920, after which the building was occupied by the local *Highland Park Herald* newspaper. To the left, the G. W. E. Griffith House is visible on its original site. (Virginia Neely collection.)

G. W. E. GRIFFITH HOUSE. Griffith had this house built in 1902, and its design is attributed to Fred R. Dorn. It was moved around the corner to accommodate Griffith's new commercial building and then to Echo Street as the Sunbeam Theater was constructed. The American Foursquare residence is listed as Los Angeles Historic Cultural Monument No. 374. (Photograph by the author.)

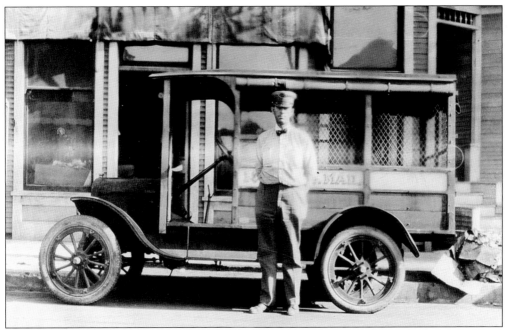

THOMAS DANIEL BECK. By 1919, Beck had started his job as a postal worker at the Highland Park station. He is shown here in front of a Ford Model T post office delivery truck, as the postal service had just made the switch from horse-drawn vehicles. Beck was the grandfather of local historian Virginia Neely. (Virginia Neely collection.)

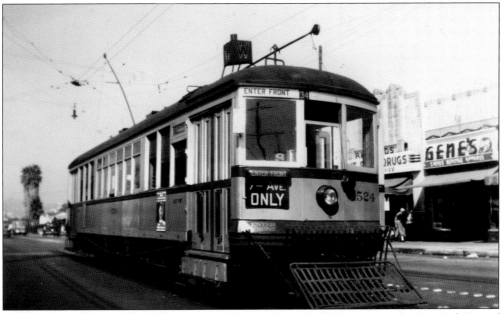

W CAR NO. 1524 ON YORK BOULEVARD. During the early 20th century, the Big Red Cars of the Pacific Electric plied Pasadena Avenue. Two smaller car lines were established as connectors for the community. This one, shown on October 14, 1942, terminated near Avenue 50 at the Highland Park Electric Tract. Most likely it was set up as a means of bringing potential home buyers to the subdivision. (Author's collection.)

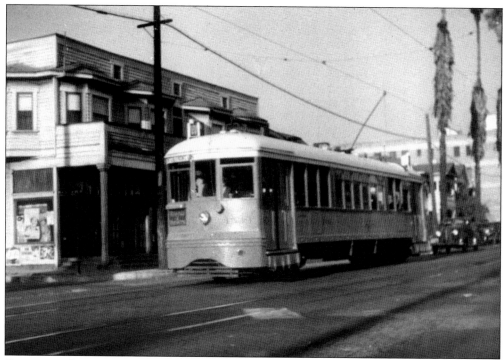

STREETCAR STOPS AT MONTE VISTA MARKET. This 1950 photograph shows Car No. 1539 at Avenue 52 and Monte Vista Street four years before the front of the little market was covered with stucco. Still open today, it may be the oldest continuously operated grocery market in Highland Park. The W Line was abandoned in 1958 when the streetcar lines in the city were converted to buses. (Author's collection.)

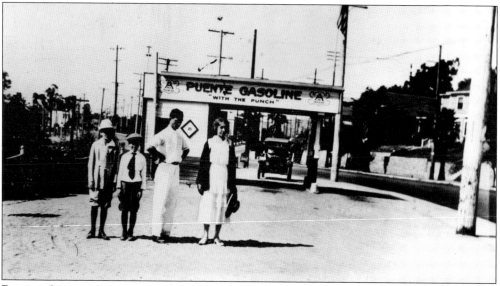

PUENTE SERVICE STATION. In 1922, a family poses before the little gas station that stood where the Highland Park Senior Center is today. The house on the far right, built in 1898, is virtually unaltered. The library is directly behind the station. The company motto, "With a Punch," has been painted on the canopy. (Virginia Neely collection.)

SYCAMORE GROVE COMFORT STATION. Built in 1911, this Spanish Colonial Revival restroom building at Sycamore Grove is the only remaining example of several that were designed for city parks by the firm of Hunt and Burns. To the left are a snack stand of similar vintage and a band shell where John Phillip Sousa would conduct when visiting his friend Dr. Edwin Hiner. (Photograph by the author.)

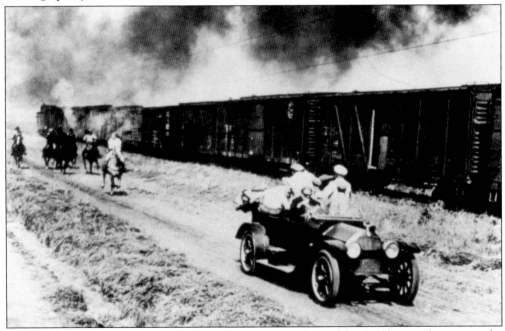

FILMING A SILENT MOVIE. Sycamore Grove was frequently used for the filming of movies in the days before talkies. Here a director in a moving Overland car calls the shots with the cameraman next to him. The Los Angeles and Salt Lake Railroad, which ran behind the park, was used in scenes such as this one, around 1918. (Highland Park Heritage Trust.)

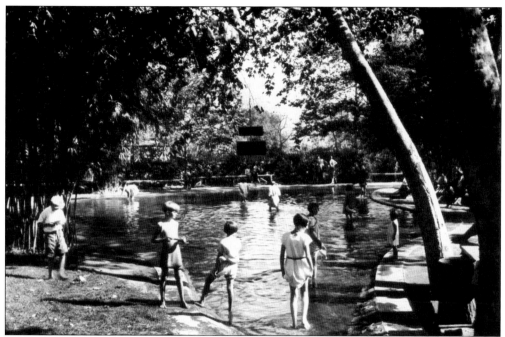

WADING AT SYCAMORE GROVE. In this 1920s photograph, children wade in a shallow pond that was in Sycamore Grove Park until the North Branch of the Arroyo Seco was put underground. A municipal pool at the current site of the Highland Park Senior Center was filled in with rubble of the debris from a landslide at Riverside Drive and several dynamited bridges. (Virginia Neely collection.)

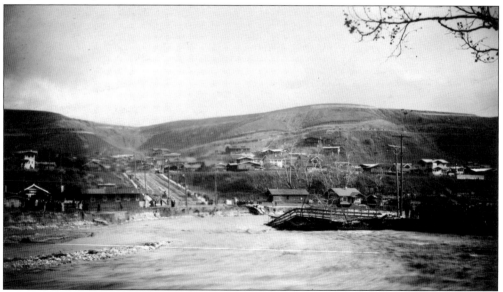

AVENUE 43 BRIDGE DESTROYED BY THE FLOOD. On February 21, 1914, pouring rains sent raging floodwaters down the Arroyo Seco. As Charles Lummis watched the waters rise and threaten El Alisal, he became worried about the 20,000 rare bird eggs stored in his basement that had been donated to the Southwest Museum. He cut eucalyptus trees down and formed a cofferdam, saving his house and the eggs. (Virginia Neely collection.)

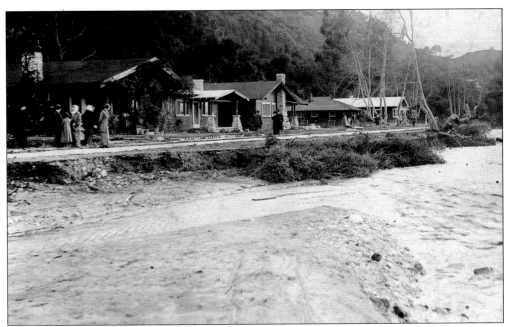

HOMER STREET IS WASHED AWAY. Spectators stand in awe as Homer Street disappears into the floodwaters. The Arroyo Seco had flooded many times before, but this was by far the worst one yet. The area would suffer several more major floods over the next 20 years. (Virginia Neely collection.)

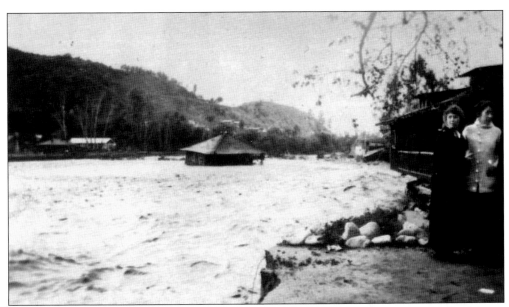

A HOUSE FLOATS DOWN THE ARROYO. The destruction of 1914 was widespread as the floodwaters carried everything from houses to railroad cars downstream. The *Los Angeles Times* reported that over 50,000 people came to view the damage the day of the flood. (Virginia Neely collection.)

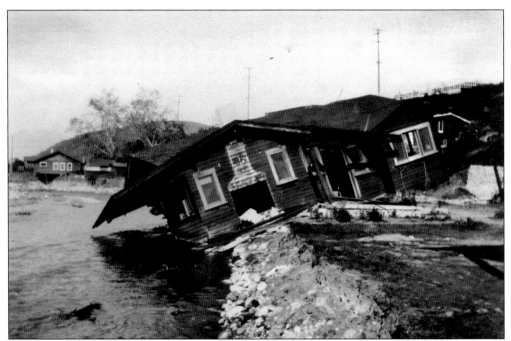

ANOTHER HOME IS LOST. "Water, water, and still more water," wrote one photographer in a scrapbook of images from the flood. Professionals as well as amateurs were there to record the calamity. Soon the finger pointing started, and officials were called on the carpet. Lawsuits were filed as many victims sought relief. The movement began in earnest to find a solution to the raging waters. (Virginia Neely collection.)

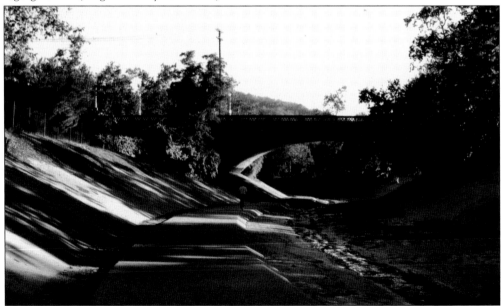

TODAY'S CONCRETE ARROYO SECO. It took over 20 years and two more floods before the Arroyo Seco was tamed by the Army Corps of Engineers. This 1988 view of the Avenue 60 Bridge shows the channel. There has been talk of trying to restore the bed of the Arroyo, but care must be taken in any restoration to maintain the flood-control capabilities. (Photograph by the author.)

Six

LEAN TIMES
AND WAR YEARS

Highland Park had grown from a subdivision of sheep pastures in 1885 to a bustling community in just four decades, mirroring the explosive growth of Los Angeles. By the end of the 1920s, the area encompassed that of a medium-sized city of the day. Business was booming, and the quality of life was good. Midwesterners brought their value systems and settled the area. They even elected a candidate from the Prohibition Party to Congress, Charles Randall, former publisher of the *Highland Park Herald*.

Several obstacles remained. The Arroyo Seco had to be tamed, yet the Arroyo Seco parklands were an important asset. Another contingent pushed for a parkway road up the Arroyo between Los Angeles and Pasadena. The road was not a new idea. Judson and Morgan's original tract map showed the "Los Angeles and Pasadena Boulevard" at the Arroyo Seco. The road was really just an idea that had been brushed aside every time the Arroyo flooded. A concerted effort to put the stream in a flood-control channel was working its way through the government bureaucracy, but it was taking time.

New concrete bridges were built over the Arroyo, but some of them were lost in a 1934 flood. The York Valley area flooded at the same time, when the North Fork of the Arroyo Seco overflowed. That stream was quickly put underground. York Valley itself was also rapidly growing. The name of the main street had been changed from New York to York in order to lessen the stigma associated with an area that had become known as "Poverty Flats." The new name was successful, and the area began to prosper.

The Great Depression put on the skids, but not the brakes, and the opening of the Arroyo Seco Parkway would forever change the idyllic feel of the Arroyo Seco. Pasadena Avenue became Figueroa Street. Then came World War II.

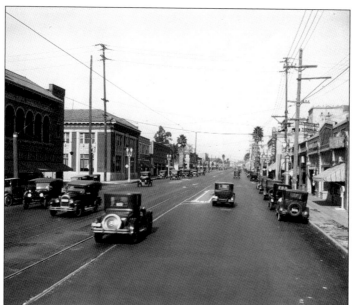

PASADENA AVENUE AT AVENUE 56. Traffic bustles along Pasadena Avenue in 1925. The corner is much the same today, with three of the buildings now listed as Los Angeles City Historic Cultural Monuments. The Security Trust and Savings Bank Building (HCM No. 575) near the center, completed in 1923, was designed by father and son architects John and Donald Parkinson. (Security Pacific Collection, Los Angeles Public Library.)

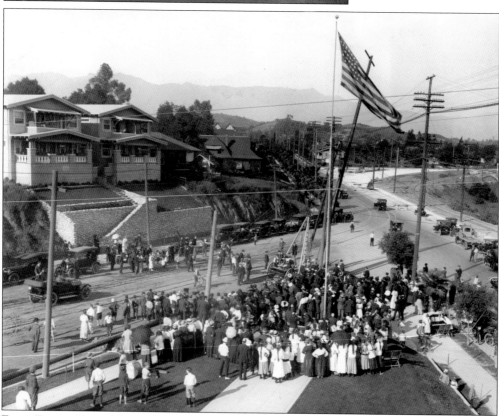

FIRST POWER POLE. This site by the library experienced the installation of the first pole in the Los Angeles citywide power system on March 30, 1916. It was the beginning of the fulfillment of Ezra Scattergood's dream to supply power to every home and business in the city. By the 1930s, that dream would become a reality. (Security Pacific Collection, Los Angeles Public Library.)

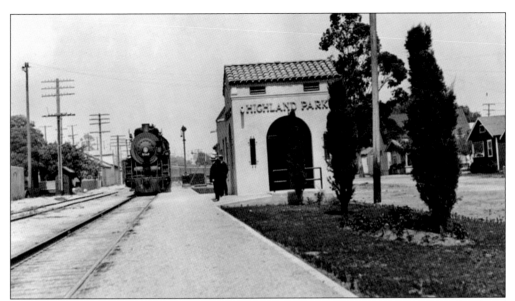

HIGHLAND PARK STATION. A Los Angeles–bound Santa Fe train pulls into the small railroad station at Marmion Way and Avenue 58. The station was torn down in 1965. However, the site is again the local railroad station, this time for the Metropolitan Transportation Authority's Pasadena Gold Line. (Security Pacific Collection, Los Angeles Public Library.)

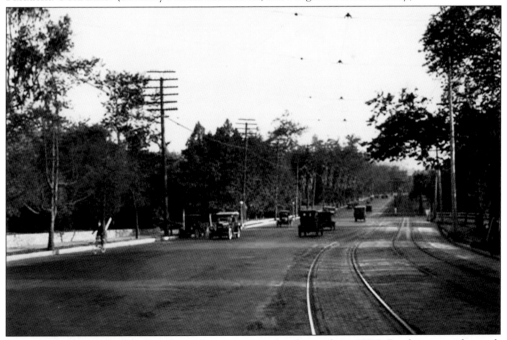

SYCAMORE GROVE PARK. Pasadena Avenue passes by the park in 1926. By this time, the park and its Sunken Gardens had become the venue for annual picnics held by expatriates from every state but Iowa (as they were always in Long Beach). These picnics were attended by hundreds of people each year, and the practice would continue until the early 1960s. The Sunken Gardens were removed in the 1980s without community input. (Security Pacific Collection, Los Angeles Public Library.)

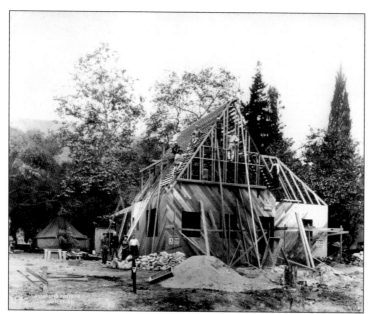

CONSTRUCTION OF THE HINER HOUSE, 1922. Edwin M. Hiner served as director of the U.S. Army band at the same time John Phillip Sousa was directing the marine band. He built this house, designed by renowned theater architect Carl Bowler, across from Sycamore Grove in 1922. An unidentified man in uniform stands with Dr. Hiner's stepson Everett Moore, Anna Hiner, and Dr. Hiner. (Troy Evans collection.)

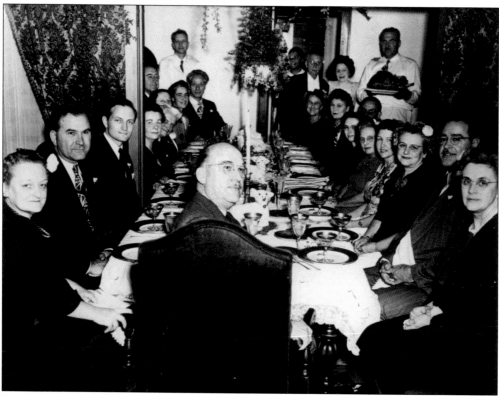

THANKSGIVING AT THE HINER HOUSE. Dr. Hiner is seated at the head of the table with Anna to his right in this 1930s gathering of a few close friends and family for the holiday dinner. Hiner was in charge of the music department at the University of California at Los Angeles by this time. His friend John Phillip Sousa always stayed in the guesthouse, known as "Sousa's Nook," whenever he came to the city. (Troy Evans collection.)

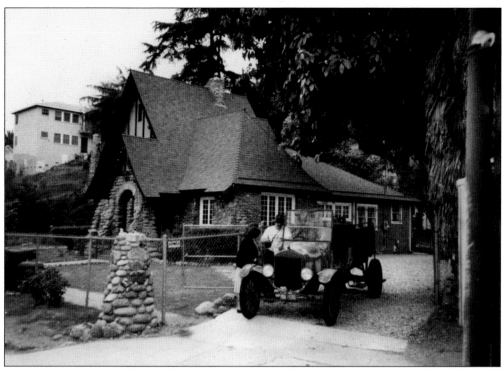

THE HISTORIC HINER HOUSE. The Hiner House is one of the most recognized historic resources in Highland Park today and is listed as Historic Cultural Monument No. 105. Across the street in Sycamore Grove Park is the band shell where Sousa would conduct when he visited Hiner. That structure is now named the Sousa-Hiner Bandshell. (Photograph by Geoffrey Willis.)

HINER TRAINING THE NEXT GENERATION. Dr. Hiner ran a well-known band school when he was in Kansas City. In Highland Park, he picked it up again, training young musicians at his home. This photograph was taken in the backyard in the 1940s, toward the end of his life. Many of his students became professional musicians and some played for the Los Angeles Philharmonic. (Troy Evans collection.)

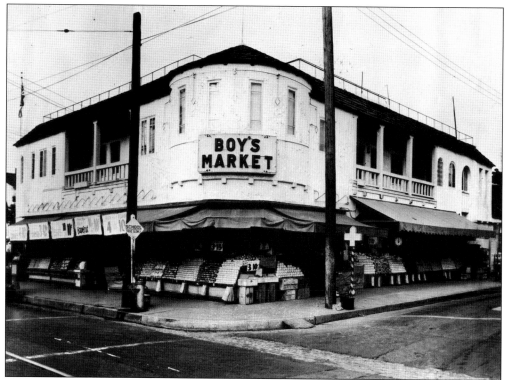

SECOND BOYS MARKET. Located at Monte Vista Street and Avenue 55, this was really the first full market for the Goldstein brothers, who had first operated a large fruit stand on Telegraph Road. Family members lived above the store, shown in this 1937 image. The building was razed in the 1980s to accommodate a new playground for the Monte Vista Street School. (Boys Market photograph, Virginia Neely collection.)

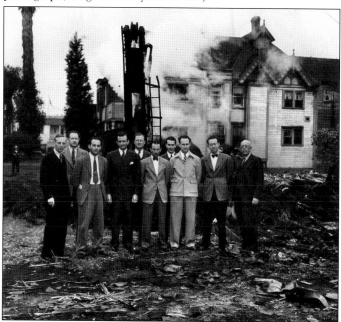

GROUNDBREAKING FOR NEW MARKET. "The Boys"—(second from left to second from right) Max, Joe, Eddie, Al, and Bunny Goldstein—stand at the new store site on Monte Vista in 1940. Behind them is the original Monte Vista Schoolhouse, later razed for parking. The new building eventually became offices for Boys Market, which was bought out by Ralphs in the 1990s. This new store was torn down for a school. (Photograph by White Studios, Virginia Neely collection.)

Sy Perkins Market. Perkins originally opened his market in the G. W. E. Griffith Building around 1910. The market moved to several locations before it was bought out in the 1960s. This undated photograph appears to have been taken between the late 1930s and early 1950s. The vaulted ceiling indicates a larger building. Only the original Griffith Building remains. (Author's collection.)

Dick's Market, c. 1940. Opening in 1930, this local store was a mainstay in Highland Park until competition forced its closure in the 1960s. Quite a celebration must have been going on in this yuletide shot. The building, located at 6015 North Figueroa Street, was torn down in 1966. A mini-mall occupies the site today. (Author's collection.)

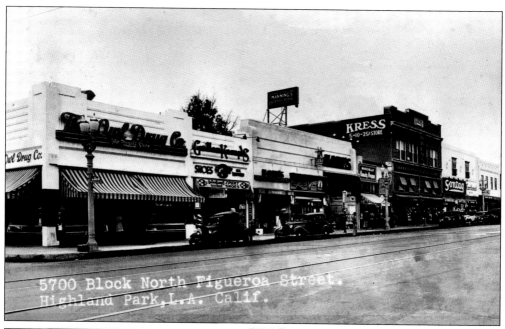

5700 Block North Figueroa Street. Highland Park, L.A. Calif.

5700 BLOCK OF NORTH FIGUEROA STREET. Pasadena Avenue was renamed so that Figueroa could be "the longest street in the world" in 1936, the year this postcard view was taken. The buildings are all still there, and so is the Manning Coffee Shop sign, even though that business closed in 1959. The parapet on Kress is gone, and the building now houses Franks Camera. (Virginia Neely collection.)

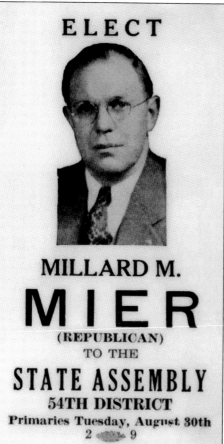

ELECT

MILLARD M.

MIER

(REPUBLICAN)
TO THE

STATE ASSEMBLY
54TH DISTRICT

Primaries Tuesday, August 30th
2 ● 9

MILLARD MIER FOR ASSEMBLY, 1932. Millard Moreland Mier lived in Highland Park from 1902 until his death in 1987. He was one of the movers of the community right up until the end, as an attorney, banker, businessman, and civic leader. He was also known for his antique car collection, which included the Cadillac occupied by Theodore Roosevelt at Occidental College (see page 40). He lost the assembly race. (Author's collection.)

HIGHLAND THEATER, JULY 12, 1942. *Tortilla Flat* is on the marquee, and the Democratic Party has its election headquarters in one of the stores in this wartime photograph of the only theater now open in Highland Park. The Lewis A. Smith–designed theater building was declared Historic Cultural Monument No. 549 on October 2, 1991. (Virginia Neely collection.)

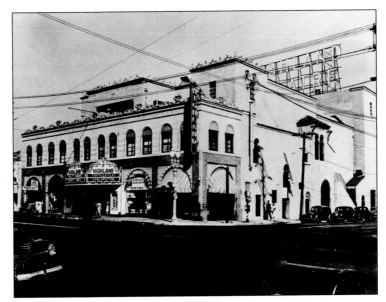

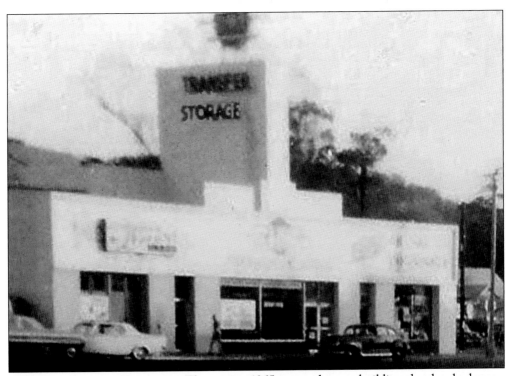

FRANKLIN THEATER BUILDING. This grainy 1965 image shows a building that has had many uses. Built in 1922 as an automobile dealership and then housing a market, this structure was renovated as a theater by architect Lyle N. Barcume in 1936. It was here that a teenage Darryl Gates (Los Angeles police chief 1978–1992) was arrested for disturbing the peace. It closed in 1952, becoming DeWitt Storage, and is now a carpet-cleaning business. (Author's collection.)

SUN RISE COURT. The bungalow court came to symbolize Los Angeles in the 1930s. This Mission Revival court was designed by New York architect Charles Conrad and built in 1921. New Yorkers Max and Lena Kagan probably believed their little court was the perfect example of the California lifestyle. The property is now listed as Los Angeles City Historic Cultural Monument No. 400. (Photograph by the author.)

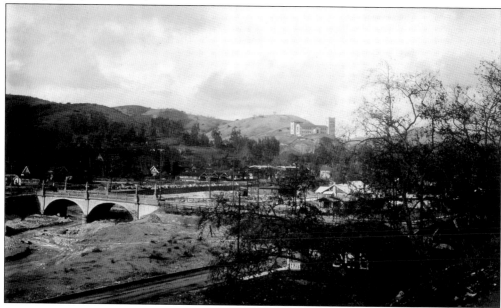

SECOND AVENUE 43 BRIDGE. The recently completed Southwest Museum crowns the hill behind this view of the new concrete arched bridge that replaced the wooden span destroyed in 1914 (see page 75). This new bridge would be replaced by the current viaduct in 1939 for the construction of the Arroyo Seco Parkway. (Southwest Museum collection, AS1-571.)

ARROYO SECO PARKWAY IS OPEN. Officially opened to traffic on December 30, 1940, the road known by most as the Pasadena Freeway was a major accomplishment celebrated with speeches, parades, plenty of publicity, and this program. The bucolic Arroyo would never be the same with this modern street. The outer lanes were concrete and the inner lanes were tar. (Highland Park Heritage Trust.)

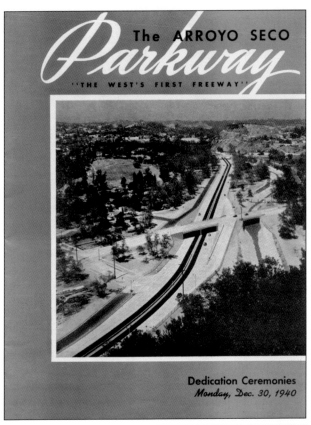

THE PARKWAY IN USE, 1945. Traffic rolls down the parkway in this photograph, taken at the end of World War II. Santa Fe Hill is visible in the background. The cars have no front plates; in 1945, the state only issued one plate to save for the war effort. These were the first new plates since 1941. In 1944, each car only received a window sticker. (Author's collection.)

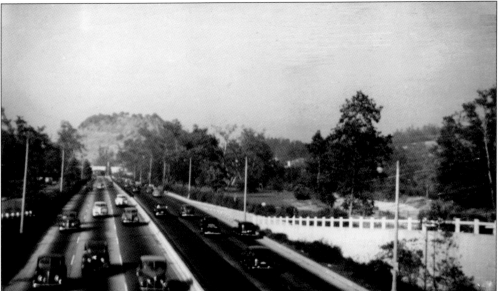

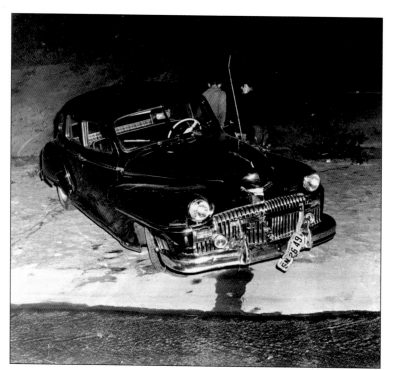

NEW CAR IN THE CHANNEL. The opening of the freeway brought new issues. The speed limit was first set at 45 and then raised to 55. However, the average speed tends to be higher. This brand-new 1947 DeSoto either lost control or was forced off the road. The car was likely repaired, as automobiles were pretty tough back then and the damage appears minor. (Photograph by Lloyd B. Fisher.)

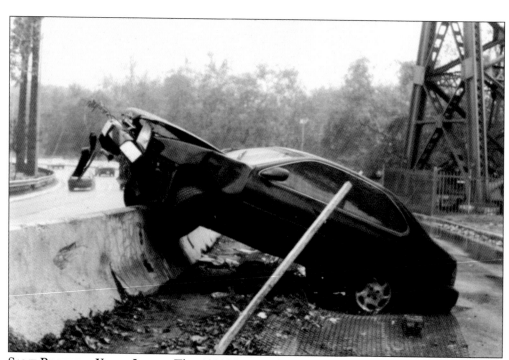

SAME PROBLEM, YEARS LATER. This 1991 Nissan Altima lost control in a light rain and slipped over the concrete embankment. The driver swore she was not speeding, but with the average speed at 70 miles per hour, the odds for wrecks can be high. She and the previous driver were lucky. There have been a number of fatal accidents over the years. (Photograph by the author.)

FRAMING GRACE PRESBYTERIAN CHURCH. With World War II over, building began again in the area, but in a different manner. New structures were often meant as replacements or for infill. The church in this 1947 photograph had outgrown the small Mission Revival structure at left, which was soon renamed Stewart Hall in honor of the pastor who died just after completion. (Photograph by Lloyd B. Fisher.)

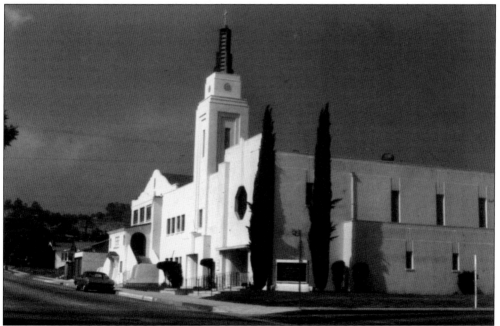

GRACE PRESBYTERIAN CHURCH COMPLETED. The completed sanctuary, pictured in 1981, displays a traditional massing with art deco detailing. It reflects the conservative aesthetics held by the people of Highland Park—a tolerance for some change, but a definite hold on their roots. Today there are many churches in Highland Park representing almost all creeds. (Photograph by the author.)

89

FOURTH HIGHLAND PARK POST OFFICE. This art deco building on Avenue 59 served as the local post office from 1932 until the present building was constructed in 1955. The office had grown to the point that by 1949 it was processing 23,000 letters daily. Today the processing is handled in Eagle Rock, but the Figueroa office remains as full service. A second post office opened on York Boulevard. (*Highland Park Journal.*)

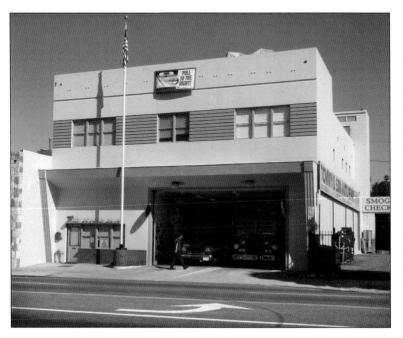

NEW ENGINE COMPANY NO. 12. The 1903 fire station (see page 68) was torn down in 1948, at which point the fire department worked out of a tent by Avenue 55 until the new station was completed on the original site in 1949. The department is again considering a new station. (Photograph by the author.)

Seven

HIGHLAND PARK SLEPT

World War II and the immediate building improvements that occurred in its aftermath were soon overshadowed by a profound change that affected Highland Park and its neighbors. As veterans re-entered civilian life, there was an acute need for housing. Los Angeles had swelled in population during the war, and the new people, mostly single defense workers, were accommodated by the conversion of older homes to rooming houses in the more built-up areas such as Highland Park. The demand for family housing called for new subdivisions, and the postwar development community was ready to provide. Neighborhoods arose in the San Fernando and San Gabriel Valleys, Orange County, the South Bay, and other formerly sparsely developed areas. Some development occurred on nearby Mount Washington, but Highland Park, with its mature housing stock, remained fairly stable. However, the community was aging.

As younger generations fled to the suburbs, the Highland Park area began to gray. By the late 1950s, businesses were beginning to leave in favor of greener pastures in newer communities. In 1961, a proposal was advanced by the business community to create a new downtown for Highland Park. Councilman John Holland agreed to study the matter, which got as far as a Planning Department report. The report recommended leveling the central core along Figueroa Street and creating a new strip mall–style business district. The surrounding housing would be leveled for parking. The plan died, as there was no concerted effort to move it forward. Two decades later, a proposal to take down several blocks along Figueroa for an enclosed shopping mall did not even get as far as the earlier one. The only major corporation that was interested was the now-defunct discount chain Zodys.

Changes did occur in the housing area, as two-story apartment structures started to replace earlier single-family homes. The area had been given high-density zoning in 1946, but the developers were concentrating on the outlying areas that had plenty of space. This would change by the 1980s.

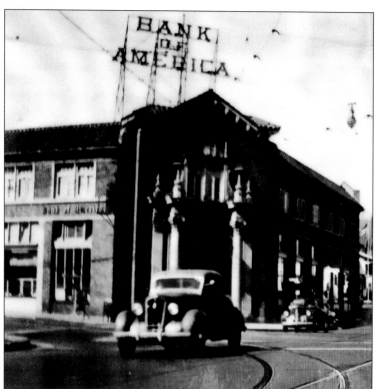

YORK JUNCTION AND THE BANK. The dusty roads of the 1880s have matured by the time of this August 11, 1946, photograph. In the image, the tracks of the W Line turn onto York, and the Arroyo Seco Bank has become the Bank of America. Now occupied by the Union Bank of California, the building is listed as Historic Cultural Monument No. 492. (Photograph by Ray Younghans.)

HIGHLAND CAR WASH, 1958. Automated car washes began to appear in Southern California soon after World War II. This one along Figueroa Street is still creating the suds. Even the iconic sign remains in place, though without its neon. The large house shown in this postcard has been demolished and replaced with a fried chicken stand that now cashes checks. (Author's collection.)

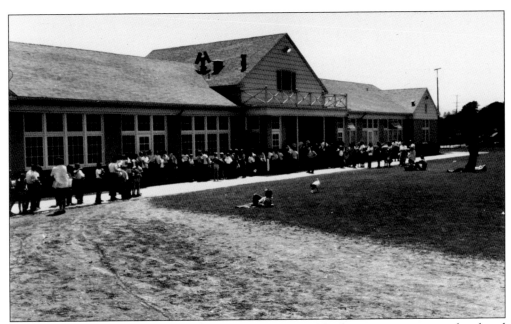

HIGHLAND PARK BATHHOUSE. Pictured at its opening in 1951, the new swimming pool replaced one that had been in a natural hole across the street, where the senior center is now located. The bathhouse was designed to blend with the existing recreation center (see page 69). Today the new building stands in stark contrast to this more traditional structure. (Author's collection.)

BASEBALL AT THE RECREATION CENTER. A young ballplayer takes a swing in this 1950 photograph snapped by the author's father. The original Community Clubhouse can be seen in the background. The venue acted as the center for much of the social activity in the community for several decades. This scene is still found today, even if the background has changed. (Photograph by Lloyd B. Fisher.)

WINTER WONDERLAND. Following a rare snowfall on January 11, 1949, this view from the front porch of the Ritzman house shows the Benner Street and Avenue 57 neighborhood dusted with white powder. The house in the foreground still stands, but the larger one farther back was replaced by apartments in the 1960s. The background is now the site of Debs Park. (Photograph by Evelyn Ritzman, author's collection.)

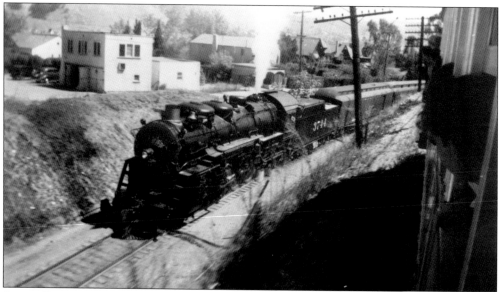

STEAM ENGINE ON SANTA FE TRACKS. A disappearing scene is captured as Santa Fe No. 3744 plows by Woodside Drive in the 1940s. Soon the engines would all be diesel. This photograph was taken from a Los Angeles Transit Company Yellow Car. By 1958, the company's W Line would also be gone. The scene in the background has changed little. (Author's collection.)

STREETCAR ACCIDENT ON PIEDMONT AVENUE. A motorcyclist lies on the ground after hitting W Line Yellow Car No. 1523 on March 10, 1946. Since the cars were in a fixed right-of-way, they could only stop to avoid an accident. This view was taken from the library site. (Photograph by L. T. Gotchy, Los Angeles Public Library.)

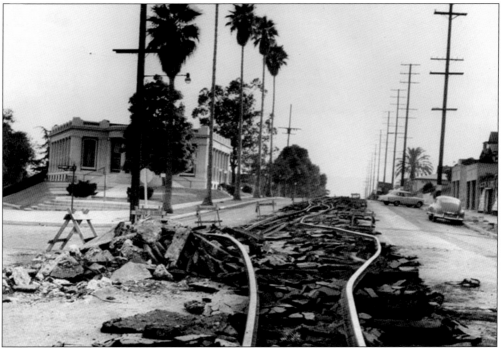

END OF THE W LINE. Streetcar tracks are removed at Piedmont and Figueroa on July 1, 1958, as the rail line yields to bus traffic. The Red Car on Figueroa had been gone since the late 1930s. By the next year, the library in the background would also come down. (Photograph by L. T. Gotchy, Los Angeles Public Library.)

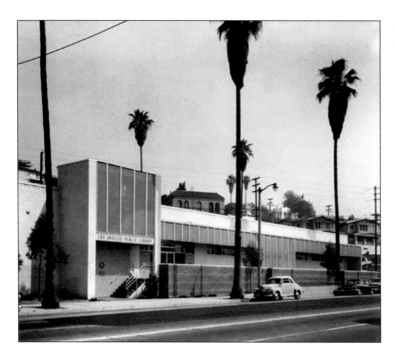

NEW LIBRARY. The new Arroyo Seco Regional Library, pictured here, replaced the venerable Carnegie building in 1960. Hailed as state of the art, the John J. Landon–designed building featured rooftop parking for patrons. However, the constant movement of cars on the roof soon caused it to leak, and that feature was eventually abandoned. The building was replaced in 2003. (Los Angeles Public Library.)

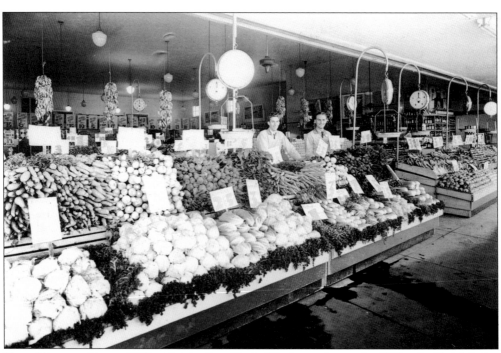

YORK MARKET, EARLY 1950S. Originally a Piggly Wiggly market in the 1920s, the York Market had just been remodeled when this photograph was taken. Part of an open-face building, the produce stands spread out onto the sidewalk when the facade was rolled up. Florescent lighting was used at night. The county soon required all open facades to be closed, and the store was again remodeled. (Author's collection.)

LUNCH COUNTER, 1940S. This was one of several small restaurants that dotted the area. Family-operated and serving home-style cooking, these businesses usually did a strong breakfast and lunch trade, but tended to close before dinner. The patrons give a glimpse of the demographics of the area at the time. This particular restaurant was most likely on Figueroa or York, but some were located on Monte Vista. (Author's collection.)

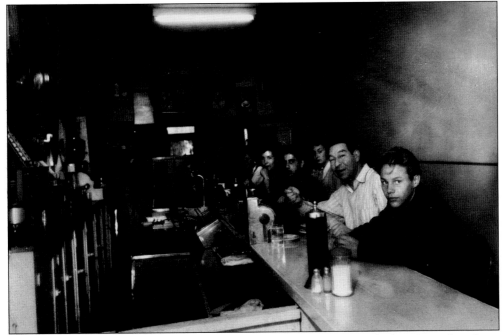

SODA FOUNTAIN, 1950S. Shown here is a soda fountain on Figueroa. The best remembered was Fossilman's, which still has a location in Alhambra. One man at the counter has soup. Note the teenager with the James Dean look in the front. (Photograph by Glass Photo, author's collection.)

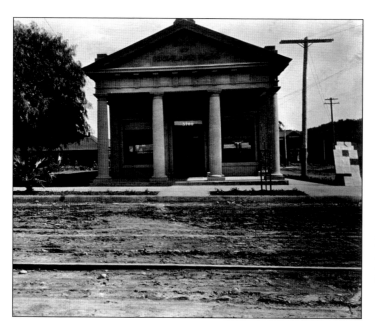

BANK OF HIGHLAND PARK, 1906. The following four photographs show the evolution of the first bank building in Highland Park. In this early view, the streets are unpaved and new curbs and sidewalks are present. In the right background is the Latter House, Los Angeles Historic Cultural Monument No. 366. The windows in the house are now gone, replaced by a chimney. (Author's collection.)

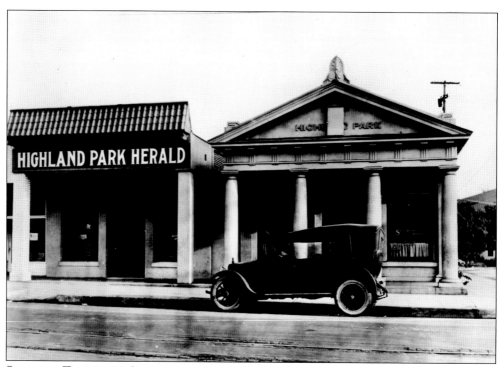

SECURITY TRUST AND SAVINGS BANK, 1922. The Highland Park Bank has recently merged, and the new bank has moved. The following year, the bank moved to its new building (see page 78), and this structure was soon occupied by the Los Angeles Building and Loan Association. The local newspaper occupies the old post office. (Security Pacific Collection, Los Angeles Public Library.)

HOME SAVINGS OF AMERICA, 1959. After 10 years as the North American Savings and Loan Association (1941–1951) and three as National American Fire Insurance, the building was bought and remodeled in 1954. The newspaper has moved out and would soon set up offices in the Sunbeam Theater building before constructing its own facility in the 1960s. (Northeast Newspapers.)

WASHINGTON MUTUAL, 2007. Home Savings remodeled the building again and expanded it to the rear in 1971 to fit its corporate image, complete with two tile murals by artist Millard Sheets. In the early 1990s, the old post office was razed and the bank building was expanded into that space. For over 100 years, it has remained a bank. (Photograph by the author.)

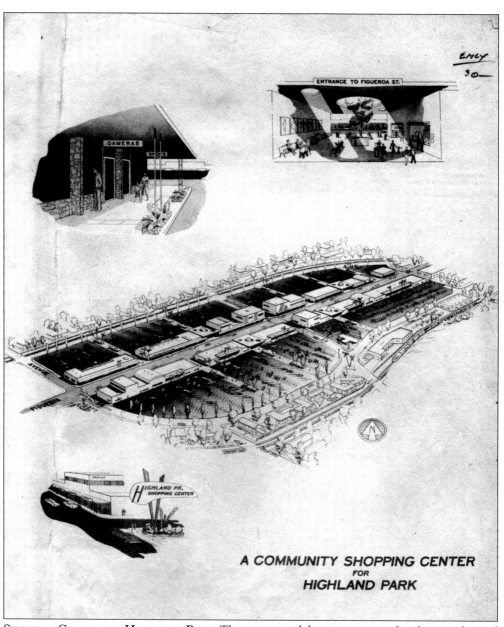

SHOPPING CENTER FOR HIGHLAND PARK. This conceptual drawing sums up the plans put forward in 1961 by the Planning Department. The image covers Figueroa Street from Avenue 50 to Avenue 60—the heart of the Highland Park business district. The goal was "urban renewal," the buzzwords of the day. By tearing down old structures of different styles and replacing them with matching new ones, the planners believed that they could completely revitalize the commercial corridor. Parking would be accomplished by tearing down all of the housing between the Santa Fe and the Union Pacific tracks. This plan received mixed reviews from the community, with the biggest concern expressed by those who would lose their homes to the bulldozer. The plan would have ripped out the entire historic core of Highland Park, including what are now 14 city monuments and one that is listed on the National Register of Historic Places. (Author's collection.)

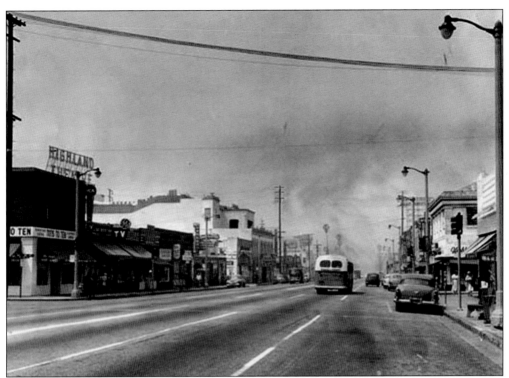

5600 BLOCK OF NORTH FIGUEROA, 1955. The area had become fully commercial by the time of this May 14, 1955, view. If the design on the previous page had been implemented, all of these buildings would be gone. (Los Angeles Public Library.)

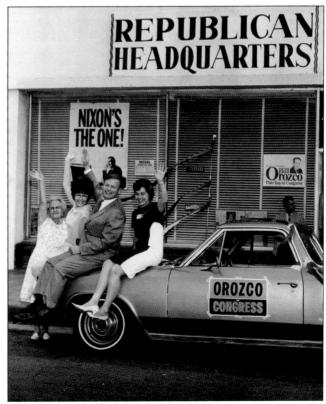

REPUBLICAN HEADQUARTERS, 1968. Los Angeles city councilman Arthur K. Snyder and his wife, Mary, sit on the hood of an El Camino along with an unidentified woman. Ella Muller, a longtime resident of Roselawn Place, is to the left. The Republican cause was headquartered in the former Franklin Theater, whose seats and screen were still in place 16 years after closing. (Photograph by Hank Friezer, author's collection.)

La Estrella. This little fast food stand was built in 1962 on the corner of Avenue 61 and Figueroa Street. It sits on a small triangle of land that remains vacant under today's building codes, directly in front of the railroad tracks as they cross both streets. The Highland Park Bathhouse can be seen poking above the roof. (Photograph by the author.)

Blend in Northeast Christmas Parade. Northeast Division commander Bob Smithson stands on the running board of an old Dodge police vehicle on December 7, 1980. Since the 1930s, the parade has been held on the first Sunday of December. In the background is the Pillar of Fire Church, a branch of the Methodist denomination. BLEND (Business for Law Enforcement, Northeast Division) is an auxiliary for the police department. (Photograph by the author.)

THE BOYS OF SOUTH AVENUE 53. Baseball on a quiet street has had a long tradition in most towns. These boys, photographed in 1992, show how Highland Park has evolved into a largely Hispanic area. These families have deep roots in Southern California. Los Angeles County sheriff Lee Baca and city attorney Rocky Delgadillo are both graduates of Franklin High School in Highland Park. (Photograph by the author.)

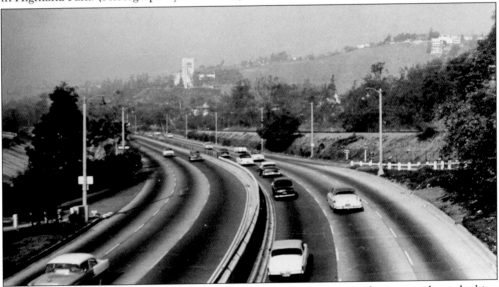

PASADENA FREEWAY, DECEMBER 1955. The Southwest Museum is seen from its perch overlooking the Arroyo Seco in this view of the freeway. The site was declared a National Historic Civil Engineering Landmark by the American Society of Civil Engineers at a Casa de Adobe Ceremony on July 23, 1999. Though the road is antiquated today, it set the early standard for the interstate system that followed. (Southwest Museum collection, S1-442.)

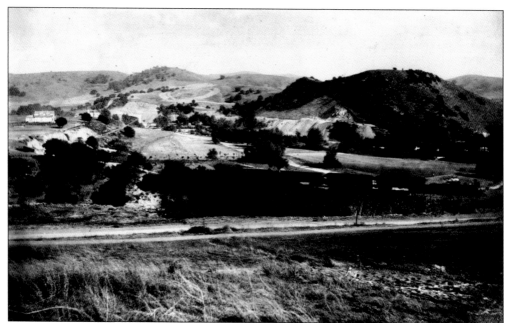

LOS ANGELES TERMINAL RAILROAD. In 1890, a second railroad opened in Highland Park. The name was changed to the Los Angeles and Salt Lake Railroad a few years later and ultimately to the Union Pacific. By the 1960s, this was no longer the main line into Los Angeles, and it terminated in Pasadena. (Security Pacific National Bank, Los Angeles Public Library.)

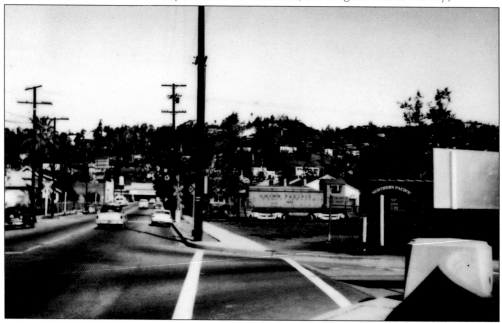

UNION PACIFIC BY THE LUMMIS HOME. When this photograph was taken in the mid-1960s, the Union Pacific was running one short train each way, each day, to keep the line open. By 1969, the company had had enough of the money pit and abandoned it. The sale of the land brought apartments along much of the right-of-way, including both sides of Avenue 43, shown here. (Photograph by Julio Esquzebel, author's collection.)

GHOST OF A CHANCE. Movie and television filming is big business in Highland Park today. This scene was shot for a television pilot with the working title *Ghost of a Chance*. The building behind the author's then-unrestored 1936 Nash is the Sunbeam Theater (page 48). For a short time in the 1980s, it was again used as a live venue and known as the Outback Theater. (Photograph by the author.)

FIRE STATION NO. 55. Councilman Richard Alatorre (center) leads citizens in the 1989 groundbreaking for the replacement of the original 1924 building. Pictured among the community members are the author's mother, Priscilla Fisher, at the far right and community activist Lucille Lemon, fourth from left. (Photograph by Hank Friezer, author's collection.)

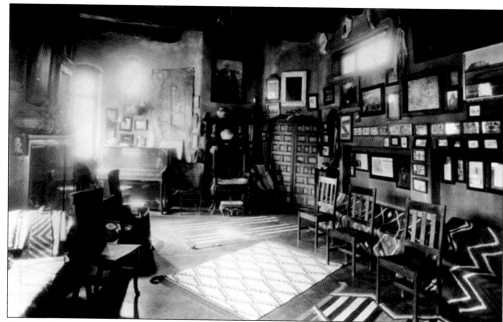

LIVING ROOM IN THE LUMMIS HOME. The Lummis Home languished for years before the Historical Society of Southern California came in and brought it back to life. The current room does not look quite as it did here, during Lummis's life, but it serves today as an educational environment on Lummis and his times. The society also maintains a water-wise garden on the grounds. (Security Pacific Collection, Los Angeles Public Library.)

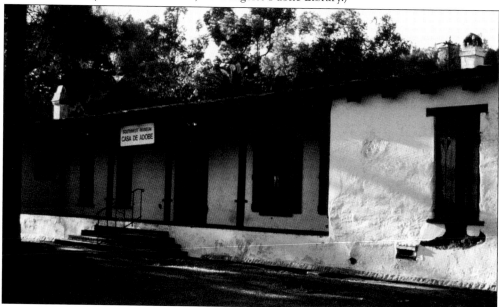

CASA DE ADOBE. Built in 1917 for the Hispanic Society by Jose Velazquez and designed by architect Theodore Eisen and his son Percy, this traditional structure was meant as a museum to show visitors life in a Mexican adobe. Declared Historic Cultural Monument No. 493 in 1990, the casa was deeded to the Southwest Museum in 1922, when the Hispanic Society disbanded. (Photograph by the author.)

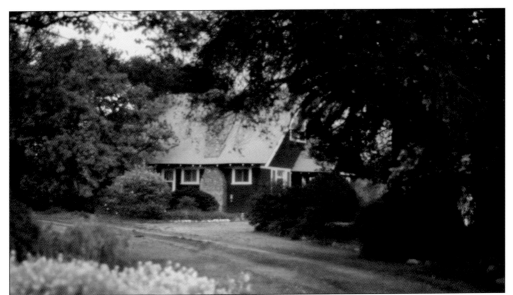

THE OLLIE TRACT. This glimpse of the past was coveted by developers for years before it became Historic Cultural Monument No. 377. The Ritzman family owned it for two generations, keeping the land and the 1907 Scott-built home intact. When the city tried to change Avenue 57 to Highland Park Boulevard, Hannah Ritzman and neighbor Glen Wolfe circulated petitions to stop it. (Photograph by the author.)

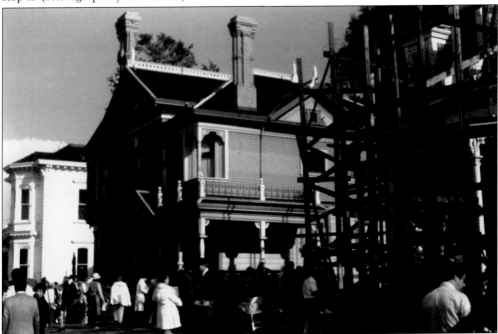

HERITAGE SQUARE CHRISTMAS. After a shaky start when two homes moved from Bunker Hill were burned by vandals in 1970, Heritage Square transported the Hale House and others to a parcel at the end of Homer Street. The Mount Pleasant House (Historic Cultural Monument No. 98) from Boyle Heights, at rear, and the Valley Knudson Residence (HCM No. 65) from Lincoln Heights, covered in scaffolding, are shown here in 1980. (Photograph by the author.)

FIRE IS ALWAYS A THREAT. The Soloman House was built in 1904 and damaged by fire in 1992. When the home was sold, the new owner proceeded to remodel it beyond recognition. Highland Park was rapidly losing its history to both the bulldozer and ignorance. The community would soon wake up from a long sleep to seize its heritage. (Photograph by the author.)

HISTORIC SURVEY TASK FORCE, 1980. Even those who worked on the East Los Angeles Community Union (TELECU)–coordinated survey had no idea the impact they were about to make. Shown from left to right are the following: (first row) Pat Samson and Martin Olivera; (second row) Mary Jones, Caroline Deuerling, Renee Kesler, Phillip Ellison, and Diana Barnwell. Not pictured is Virginia Neely. (Photograph by Hank Friezer, author's collection.)

Eight

THE NEW BOOM

At the dawn of the 1980s, Highland Park was at a crossroads. The number of historic buildings being torn down for large, poorly designed apartment projects was increasing at an alarming rate. Residents were beginning to notice that a new real estate boom had hit the area, and developers were jumping onboard as quickly as they could buy land. The prices of homes doubled and then doubled again.

In 1982, a group of residents formed the Highland Park Heritage Trust. The core membership had come from the TELECU team that had just completed the first-ever survey of historic structures in the area. Several others joined as well. Bob Ebinger, Bob Bauer, and Lou and Nora Peters, the owners of El Mio, were some of the founding members of the trust. The following year, the Heritage Trust presented a slide show on local history and wrote its first monument nomination, to save the old police station from demolition. That was soon followed by four more nominations: the Southwest Museum, the Ebell Clubhouse, the Masonic Temple, and the Yoakum House.

The City of Los Angeles was working on a new community plan as well, and the Highland Park Neighborhood Association (HPNA) was formed to work with that process.

By the mid-1990s, the work came to fruition and left Highland Park as a much better place to live and raise a family. The area again has a new light rail system, installed with community cooperation at each step—from preservation to safety to station design.

Nothing is perfect, and the new millennium still poses its share of challenges such as traffic issues, new pressures for development, and the future of long-standing institutions like the Southwest Museum. However, with the new neighborhood councils, the HPOZ board, and other programs, Highland Park has awakened and is finally fulfilling the dream that the Greater Highland Park Association had so many years ago: the true spirit of the community stepping into the future while celebrating and preserving its past.

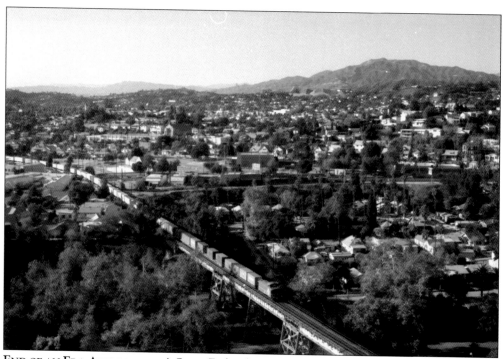

END OF AN ERA APPROACHES. A Santa Fe freight train crosses the venerable Arroyo Seco Bridge on November 26, 1983. The caboose would soon disappear from trains, and in the 1990s, the line would be converted to the Pasadena Gold Line. A 1988 Heritage Trust monument nomination has preserved the century-old bridge and continued its viability for future generations of rail riders. (Photograph by the author.)

DEDICATING POLICE SUBSTATION, 1990. When the Northeast Police Station moved in 1983, Highland Park was left several miles away from the facility. The first temporary substation on York was dedicated by police chief Daryl Gates (fourth from left), Mayor Tom Bradley, councilman Richard Alatorre, and Capt. Noel Cunningham. Virginia Neely, a Heritage Trust founder, stands to the right rear. Today the substation is in the Police Museum at the old station. (Photograph by Hank Friezer, Northeast Newspapers.)

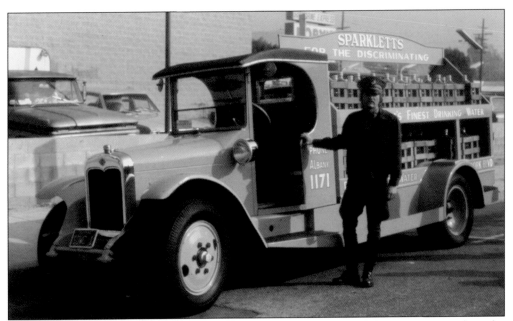

SPARKLETTS WATER COMPANY TRUCK. In 1983, the Heritage Trust began giving awards to the community for restoration and sustained maintenance. One of the early winners was this restored Sparkletts delivery truck. Sparkletts is the largest of several surviving water companies that sprang up in the area to tap the pure aquifer a century ago. (Photograph by the author.)

NORTHEAST CHRISTMAS PARADE. Shown in this December 6, 1986, photograph are Heritage Trust members Heather Hoggan (in front of her Jeep), the author and Pat Samson (standing in back) along with two high school students who carried a banner. Hoggan, who would later become the organization's president, is also one of many local artists who would band together to establish the Arroyo Arts Collective. (Author's collection.)

THE CHALLENGE TO PRESERVATION. Large apartment complexes were taking out historic homes and beginning to tower over those remaining, which in turn became more endangered as real estate values went up. Several realtors sent letters to homeowners stating that a builder would pay more for a house than a home buyer. Highland Park was thus being marketed as a builder's paradise. (Photograph by the author.)

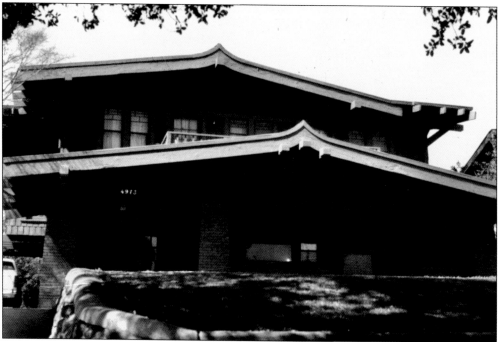

THE LINE IN THE SAND. In 1986, the Tustin House, which had been the home of the widow and family of the founder of that Orange County city, and the adjacent house were set to be replaced by a 20-unit apartment complex. After an initial defeat, the buildings were bought by preservationists. The Tustin House, built in 1912 by the Milwaukee Building Company, was declared Historic Cultural Monument No. 371. (Photograph by the author.)

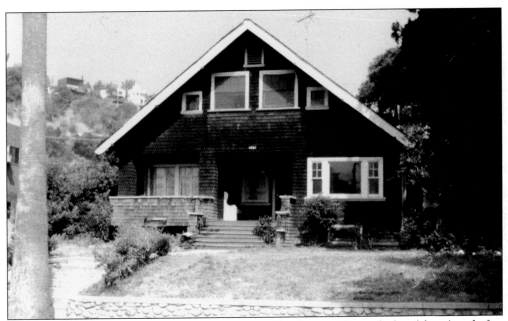

MARY P. FIELD HOUSE, THEN AND NOW. These two photographs are before (above) and after shots of the now-restored 1903 Field House, which was to be demolished along with the Tustin House. The original monument nominations failed, but the publicity in the *Los Angeles Times* piqued the interest of financiers, who were able to buy out the developers. The houses were quietly renominated by the Heritage Trust the following year, along with 10 other historic homes. The Field House was declared Historic Cultural Monument No. 372. This success was the catalyst that built the support for a more comprehensive preservation plan and advocacy for the Highland Park Historic Preservation Overlay Zone. (Photographs by the author.)

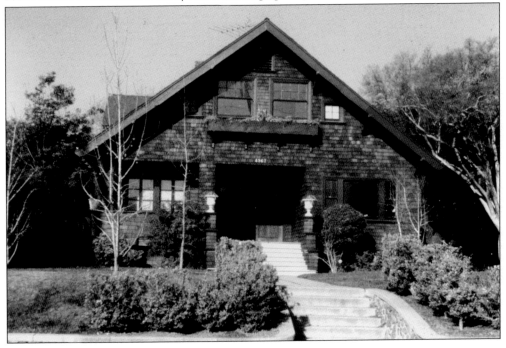

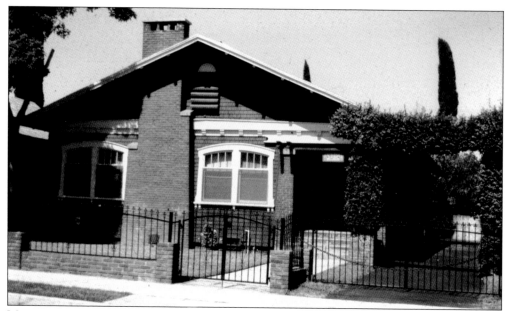

MORRELL HOUSE PRESERVED. Built in 1906 and designed by architect Charles E. Shattuck, this house was written up in *Craftsman* magazine for its unique design and livability. However, it was one of two houses that were threatened with demolition when the Heritage Trust nominated 10 others for their owners in 1988. It is now Historic Cultural Monument No. 379. (Photograph by the author.)

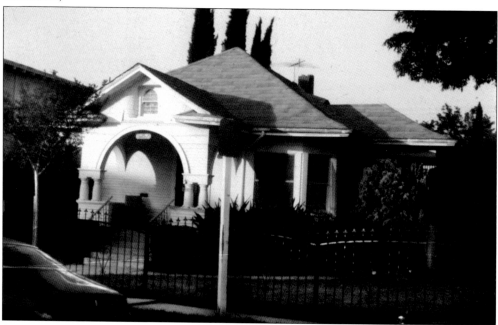

REEVES HOUSE PRESERVED. This 1904 Colonial-style cottage was set to be replaced with a 20-unit box; however, in 1988, the former home of local elementary schoolteacher Susan Reeves was instead saved. The house is now Historic Cultural Monument No. 380. The bungalow court to the left was torn down two years later and replaced by another 20-unit box. (Photograph by the author.)

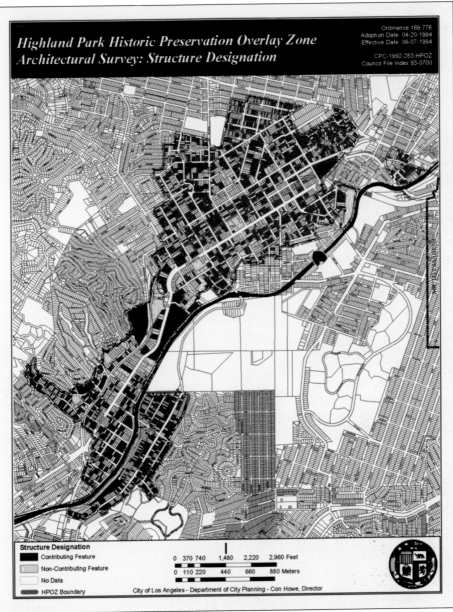

Ordinance 169,776
Adoption Date 04-20-1994
Effective Date 06-07-1994

CPC-1992-283-HPOZ
Council File Index 93-0700

**Highland Park Historic Preservation Overlay Zone
Architectural Survey: Structure Designation**

Structure Designation

- Contributing Feature
- Non-Contributing Feature
- No Data
- HPOZ Boundary

0 370 740 1,480 2,220 2,960 Feet
0 110 220 440 660 880 Meters

City of Los Angeles - Department of City Planning - Con Howe, Director

PRESERVATION ARRIVES FOR HIGHLAND PARK. On June 7, 1994, the City of Los Angeles established the seventh of what are now over 20 citywide Historic Preservation Overlay Zones in Highland Park. The citizens of Highland Park fought long and hard to get the protections afforded from demolition and inappropriate remodeling (remuddling) of historic structures. In the beginning, many said it could not be done. The size of the area and the inclusion of the commercial core were both forging new ground within the ordinance. Yet the community won, and the area covered is now protected. A five-member board reviews applications for exterior work within the area for the Department of City Planning. Developers have adapted to work within the rules set up by the ordinance. The secretary of the interior's Standards for Historic Rehabilitation are used as a guide, but a preservation plan that is tailored for the area is in the works. (Los Angeles Department of City Planning.)

115

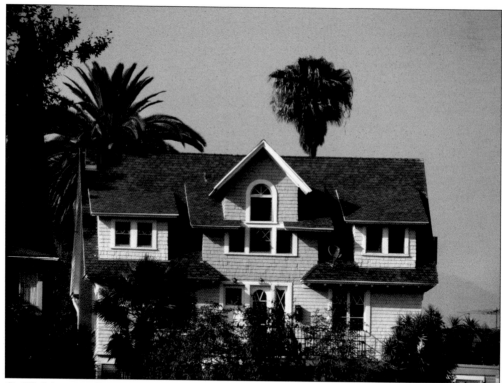

G. W. MORGAN RESIDENCE. Built in 1885, this house was the other residence of George W. Morgan, the cofounder of Highland Park. The home, which stands above Sycamore Grove Park, is not a city monument, but its exterior is now protected by the Historic Preservation Overlay Zone. (Photograph by the author.)

WYATT EARP SLEPT HERE. The lawman famous for the shootout at the OK Corral lived in this Sycamore Grove–area residence during the 1920s. He worked with the movie industry, providing technical assistance for westerns starring the likes of William S. Hart and Tom Mix. The Historic Preservation Overlay Zone prevented the house from being covered with stucco before it was learned that Earp lived in it. (Photograph by the author.)

CRAFTSMAN JACK-IN-THE-BOX. The Historic Preservation Overlay Zone board approved a new Jack-in-the-Box at the site of a burned-out muffler shop in 1997. The design was a matter of debate, as the developer argued he could not deviate from the standard plan for the outlets of the day. In a desire to improve the blighted corner, the board almost consented to that standard design (though requiring lots of landscaping to hide it) until discovering that a Craftsman design had been proposed but not built in nearby South Pasadena. The resulting building has since been photographed by tourists and touted as an interesting piece of "programmatic architecture." It shows how design can be used for new infill structures that are attractive and compatible with historic district requirements. (Photographs by the author.)

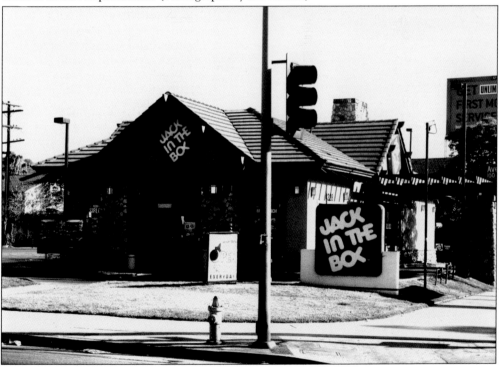

117

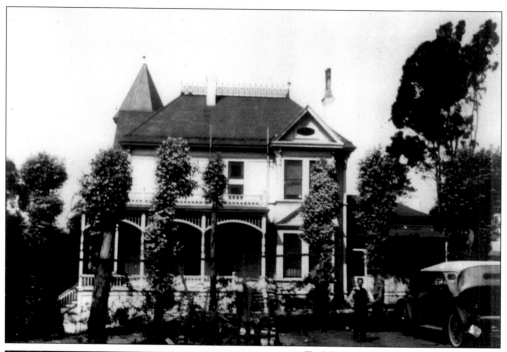

EL MIO IN THE NEW MILLENNIUM. The most recognized building that overlooks Highland Park is the Southwest Museum, but for its entire history, El Mio has been perched on the hilltop above Avenue 59. The National Register–listed house can be seen in numerous historic and recent views of the area. In this 1918 photograph, the large home retains all of its original 1887 detailing. (Tim Parker collection.)

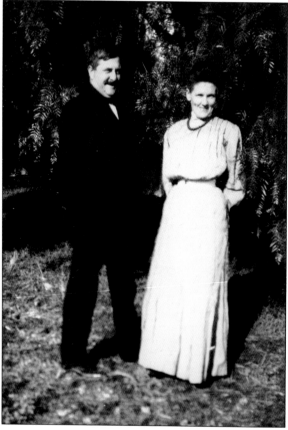

THE SMITHS OF EL MIO. Charles and Louise Smith were the third owners of the venerable hilltop mansion. In 1920, they got together with their neighbors and subdivided Tract No. 4404. This gave legitimacy to a dirt road that surrounded the house and connected to other homes built at the rear of the properties and then sold. (Tim Parker collection.)

THE SMITHS IN LATER YEARS. The extended Smith family poses by the rear entrance to El Mio in 1936. Later owners—including Lou and Nora Peters in the 1970s and 1980s and Los Angeles deputy mayor Mike Gage and his wife, Lacy—all worked at restoring the house. However, Tim and Mari Parker, the landmark's current owners, would face the toughest challenge of all. (Tim Parker collection.)

A SERIOUS SETBACK AT EL MIO. On October 19, 2001, hot torch-down roofing caused a fire to smolder within the wall for several hours until it suddenly burst into flames. Highland Park's historic Engine Company No. 12's quick response saved it from total destruction. The Parkers repaired the extensive damage, and the home remains a crown jewel above Highland Park. (Photograph by Greg Wilson, Tim Parker collection.)

EL MIO'S VIEW OF THE VALLEY. This 2004 view from the restored turret of El Mio shows a sea of palm trees with downtown Los Angeles in the distance. Prior to Tract No. 4404, El Mio was situated in the Palm Terrace Tract, which had lot lines subdivided through the house. Many of the closer trees pictured were planted in 1906, when that tract was laid out. (Photograph by the author.)

TOWN MEETING! DEL VECINDARIO

To discuss the future of housing and development in Highland Park

Tuesday, August 16 at 7:30 pm

Sunday, August 21 at 3:00 pm

Highland Hall 104 North Avenue 56

Para discutir el futuro de viviendas y el desarrollo en Highland Park

El Martes dia 16 de Agosto 7:30 de la tarde

El Domingo dia 21 de Agosto 3:00 de la tarde

THE BULLDOZER COMES HOME. Created by local artist Pearl Beach, this drawing was used on a poster for two December 1988 town meetings that convinced local leaders to ask for an interim control ordinance to hold building permits in check until a Historic Preservation Overlay Zone could be established in Highland Park. The image was later adopted by activists in South Pasadena for their fight against the Long Beach Freeway. (Author's collection.)

THIRD ARROYO SECO LIBRARY. This handsome new library replaced the 1960 building in 2004. Designed by the firm M2A (architects Thomas Michali, Barry Milofsky, and Andrew Cox), the new building incorporates the history of Highland Park, including elements from both the original Carnegie library and the Lummis Home. (Photograph by the author.)

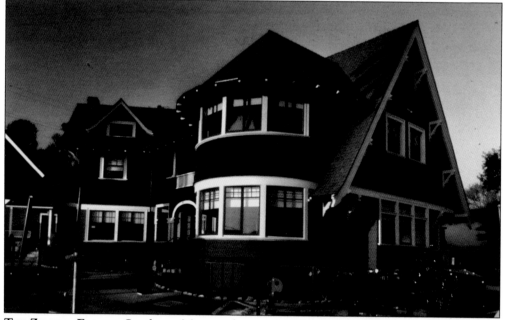

THE ZIEGLER ESTATE. Southwest Museum director Carl Dentzel bought this 1904 Shingle-style house in the 1950s with a vision that it could become a part of the greater museum complex. That never happened, and by the late 1980s, developers were craving the site. Listed as Historic Cultural Monument No. 416 and on the National Register of Historic Places, the home is used today for childcare. (Photograph by Deb Bird.)

THE GOLD LINE OPENS. The long-awaited Pasadena Gold Line finally began its service on July 26, 2003. Here Metropolitan Transit Authority No. 248 arrives at Highland Park station on opening day. The community worked for 10 years to be sure that the line would blend well with the neighborhood and not disrupt the Marmion Way Corridor, where the station is located. (Photograph by the author.)

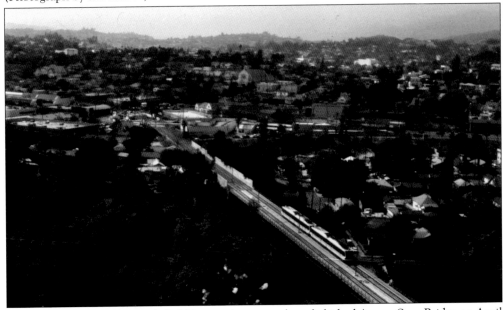

SAME BRIDGE, NEW TRAIN. A Gold Line train crosses the refurbished Arroyo Seco Bridge on April 5, 2004. The landmark bridge was altered to accommodate two sets of tracks, due to an increase in the number of trains passing. Other improvements on the line include an additional station at the Southwest Museum to allow easier access to that historic facility. (Photograph by the author.)

ACCIDENT ON FIGUEROA STREET. As traffic gets heavier and drivers more impatient, accidents happen more often. The driver of the 2002 Nissan tried to make a right turn from Avenue 60 onto Figueroa by passing a large Ford truck doing the same. This corner once housed Ben Alexander Ford, owned by the first costar of *Dragnet*. (Photograph by the author.)

GOOD TIMES CAR SHOW. Hydraulics lift 1964 and 1965 Chevrolet Impalas at the annual car show that fills five blocks of Figueroa Street at the end of each June. Staged by local businessman Jesus Rosas, the event first began in 1983 at Sycamore Grove Park. It is one of many annual events that now bring people to Highland Park. (Photograph by the author.)

ARROYOFEST AT SYCAMORE GROVE PARK. Anne Marie Wozniak tends the Heritage Trust booth at the June 15, 2003, celebration of the history of the Arroyo Seco and the area's century-old artist's colony. Highland Park attorney Millard Mier once owned the Model T fire truck in the background. (Photograph by the author.)

WALKING THE ARROYO SECO PARKWAY. The Arroyofest celebration was planned to coincide with a maintenance closure of the entire freeway that had never been done in the six decades of its operation. Beginning in Pasadena, participants were able to walk down the southbound lanes to Sycamore Grove Park. (Photograph by the author.)

PAT SAMSON AT LUMMIS DAY. Another new festival started in Highland Park in 2006 with the first Lummis Day, commemorating the life and accomplishments of Highland Park's most historic citizen, Charles Fletcher Lummis. Pat Samson cofounded the Heritage Trust and served as treasurer until her unexpected death four months after this photograph was taken. (Photograph by the author.)

LUMMIS HEIRS AT LUMMIS DAY. Jim and Suzanne Lummis—whose father was Charles's youngest son, Keith—celebrate their grandfather's legacy on June 4, 2006. Jim is a firefighter in Northern California, while Suzanne carries on her forebearer's legacy as a writer and poet. Lummis Day was held again in 2007 and hopefully will remain an annual event. (Photograph by the author.)

ONE HUNDRED YEARS OF GALCO'S MARKET. Louie and Rose Nese brought their Italian market to Highland Park from Chinatown in 1955. Their son John has made the business into the most extensive purveyor of rare soda pop in the nation. Celebrating on July 28, 2007, are, from left to right, Heritage Trust president Carmela Gomes, councilman Jose Huizar, John Nese, assemblyman Kevin DeLeon, and chamber president Max Vasquez. (Photograph by the author.)

HIGHLAND PARK TODAY. The dusty crossroads of the 1880s are now hidden by the development that has occurred in 120 years. York and Figueroa cross at the center of this photograph, taken from Santa Fe Hill on July 24, 2007. Highland Park is proud of its rich past and looks forward to an even brighter future. (Photograph by the author.)

BIBLIOGRAPHY

Beck, Sally, and Charles J. Fisher. *Listing of Los Angeles City Building Permits Issued in Greater Highland Park Area, 1887–1905*. Los Angeles: unpublished, 1991.

Cleland, Robert Glass. *Cattle on a Thousand Hills, Southern California, 1850–80*. Second edition. San Marino, CA: Henry E. Huntington Library and Art Gallery, 1951.

Cowan, Robert G. *Ranchos of California: A List of Spanish Concessions 1775–1822 and Mexican Grants 1822–1846*. Fresno, CA: Academy Library Guild for the Historical Society of Southern California, 1956.

Dumke, Glen S. *The Boom of the Eighties in Southern California*. San Marino, CA: Henry E. Huntington Library and Art Gallery, 1944.

50 Years of Masonry in Highland Park Lodge No. 382, F&AM, 1906–1956. Los Angeles: Highland Park Lodge No. 382, 1956.

Gates, Daryl F. *Chief: My Life in the LAPD*. New York: Bantam Press, 1992.

Gordon, Dudley. *Charles F. Lummis: Crusader in Corduroy*. Los Angeles: Cultural Assets Press, 1972.

Herr, Jeffrey, ed. *Landmark L.A.* Los Angeles: Cultural Affairs Department of the City of Los Angeles, 2002.

The Highland Park Business District Study. Los Angeles: City Planning Department, June 30, 1961.

Los Angeles Times. Various articles, 1886–2007.

Newmark, Harris. *Sixty Years in Southern California, 1853–1913*. Fourth edition. Los Angeles: Dawson's Book Shop, 1984.

Northeast Newspapers. Various articles in the *Highland Park Herald, Highland Park News Herald,* and *Highland Park News Herald and Journal*, 1905–1993.

Security Trust and Savings Bank. *The Five Friendly Valleys: The Story of Greater Highland Park*. Los Angeles: Highland Park branch of the Security Trust and Savings Bank of Los Angeles, 1923.

Thompson, Mark. *American Character: The Curious Life of Charles Fletcher Lummis and the Rediscovery of the Southwest*. New York: United States Arcade Publishing, 2001.

www.arcadiapublishing.com

Discover books about the town where you grew up, the cities where your friends and families live, the town where your parents met, or even that retirement spot you've been dreaming about. Our Web site provides history lovers with exclusive deals, advanced notification about new titles, e-mail alerts of author events, and much more.

MADE IN THE **USA**

Arcadia Publishing, the leading local history publisher in the United States, is committed to making history accessible and meaningful through publishing books that celebrate and preserve the heritage of America's people and places. Consistent with our mission to preserve history on a local level, this book was printed in South Carolina on American-made paper and manufactured entirely in the United States.

This book carries the accredited Forest Stewardship Council (FSC) label and is printed on 100 percent FSC-certified paper. Products carrying the FSC label are independently certified to assure consumers that they come from forests that are managed to meet the social, economic, and ecological needs of present and future generations.

FSC

Mixed Sources
Product group from well-managed forests and other controlled sources

Cert no. SW-COC-001530
www.fsc.org
© 1996 Forest Stewardship Council

Find Your Place in History.